Art Therapy

The Enchanted Forest

100 DESIGNS

COLOURING IN AND RELAXATION

illustrations by Marthe Mulkey

jacqui small

First published in the UK, USA and Australia in 2014 by
Jacqui Small LLP
74–77 White Lion Street
London N1 9PF

Text © 2014 Jacqui Small LLP

First published by Hachette Livre (Hachette Pratique), 2014
© Hachette Livre (Hachette Pratique), 2014

Illustrations: Marthe Mulkey
Translation: Alexandra Labbe Thompson

ISBN: 978 1 910254 04 2

10 9 8 7 6 5 4 3 2

Printed in China

Introduction

It does not matter if they consist of clumps of tall trees, simple groves, centuries-old trees or new plantations, forests bring us a feeling of peace and a yearning to return to our roots. They remind us that nature is magical. They can also be mysterious – both fascinating and disturbing, as they remind us of the stories we were told when we were children.

From medieval Arthurian legends to twenty-first century fantasy novels, not to mention *Grimms' Fairy Tales*, the forest is a place where anything can happen. In the deepest darkness, dangers and evil spells quicken the heartbeat of even the bravest among us. Beware of the night, when legendary creatures and giants come out and take over.

If there is one single forest that is a forest of legends, it must be the forest of Broceliande. Broceliande is an island of lush greenery in the heart of Brittany in France, where people still come to seek out the Celtic roots of its mythical world. It is a place where your imagination can run riot and where you can see supernatural beings like Morgana, Viviane and Melusina as they shape the destinies of men. Its trees, waters, moors and wild landscape inspired their first ever inhabitants, long before they became the backdrop for the stories of the Knights of the Round Table.

Here in Broceliande you can still catch a glimpse of Yvain at the magic fountain where he became the Knight of the Lion, you can walk in the footsteps of Gawain, the Sun Knight, and you can still hear the branches cracking beneath Merlin's invisible feet.

Use these illustrations to go back in time. Allow yourself to be transported by the songs of fairies as you remember stories that even the centuries cannot erase. With nothing more than some pencils and felt-tip pens, you can become the author of your very own brand new legends.

Claudine Glot
Co-founder of the Centre for Arthurian Legend
(Château of Comper, Forest of Paimpont-Brocéliande)

The forest of Broceliande today covers 7,000 hectares bordering the French departments of Ille-et-Vilaine and Morbihan. You can discover it and immerse yourself in its legends thanks to the Centre for Arthurian Legend.
www.centre-arthurien-broceliande.com

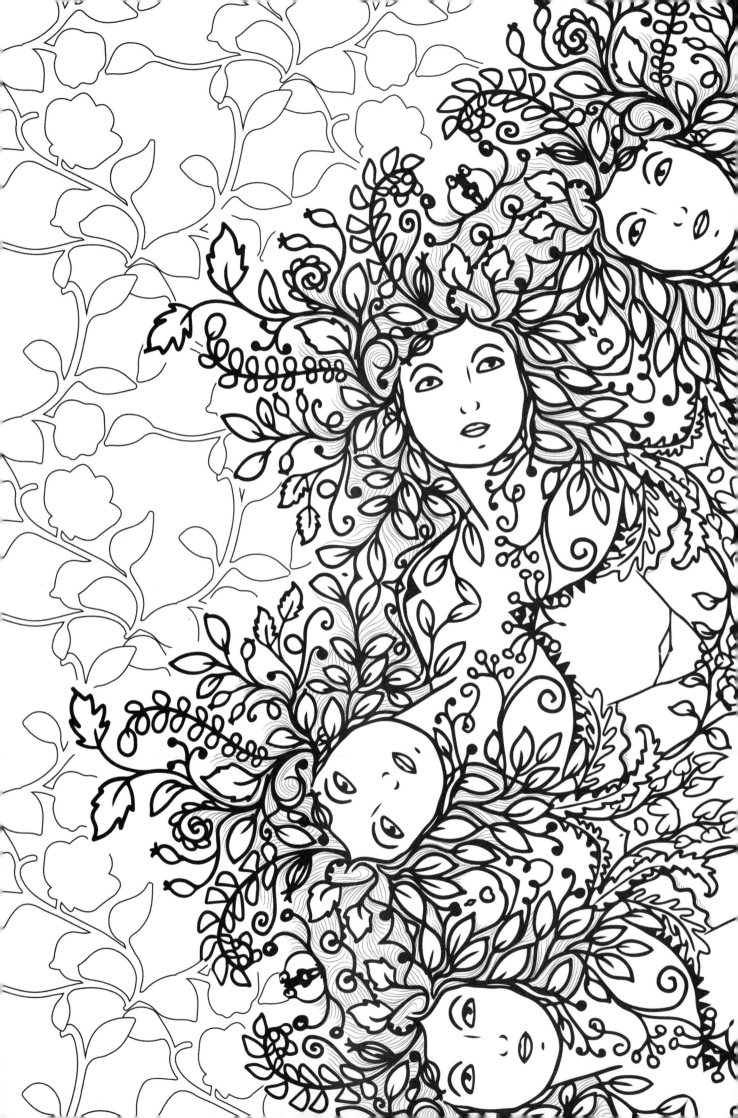

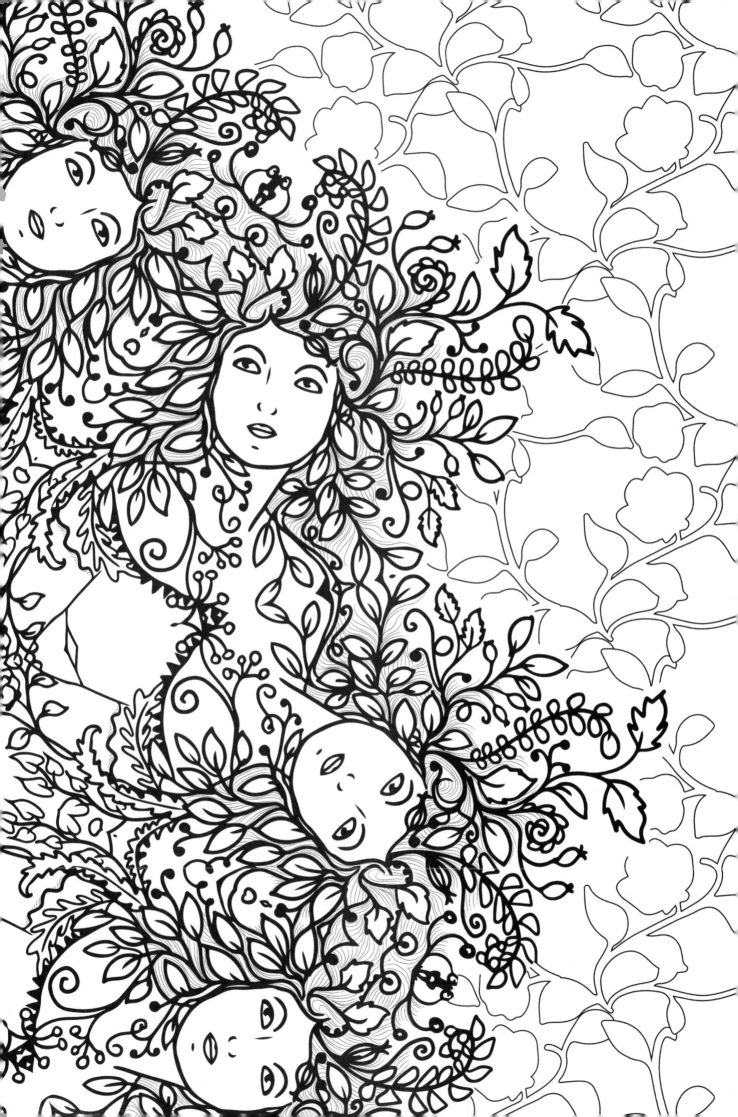

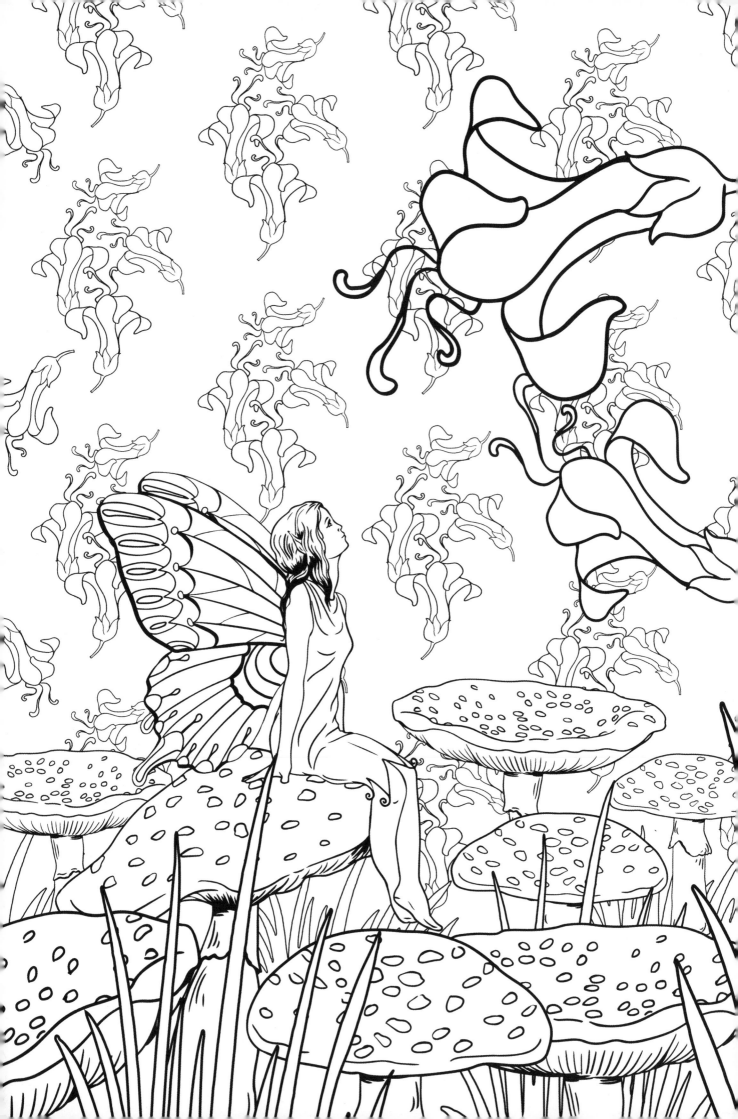

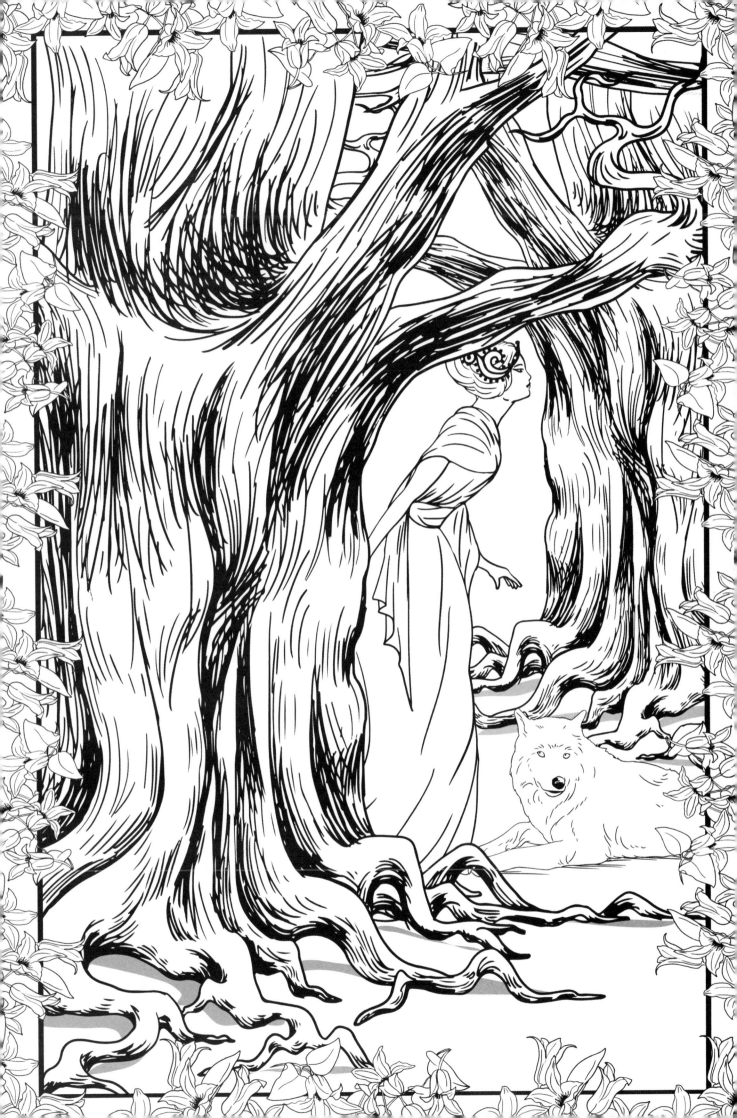

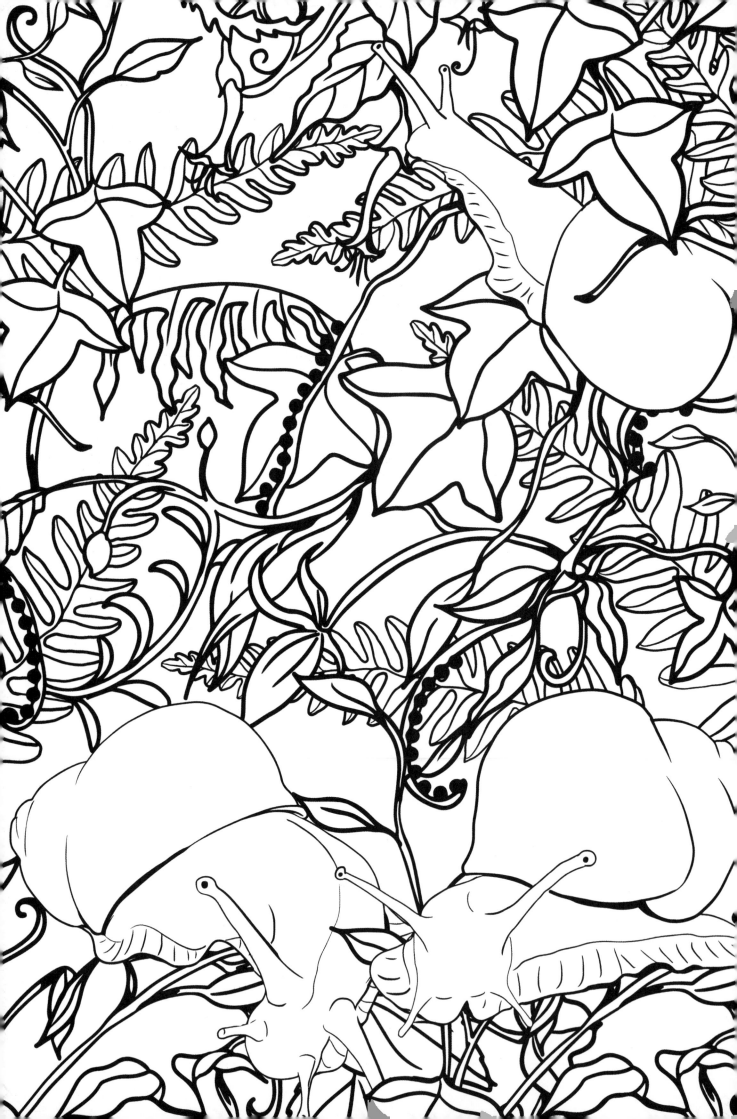

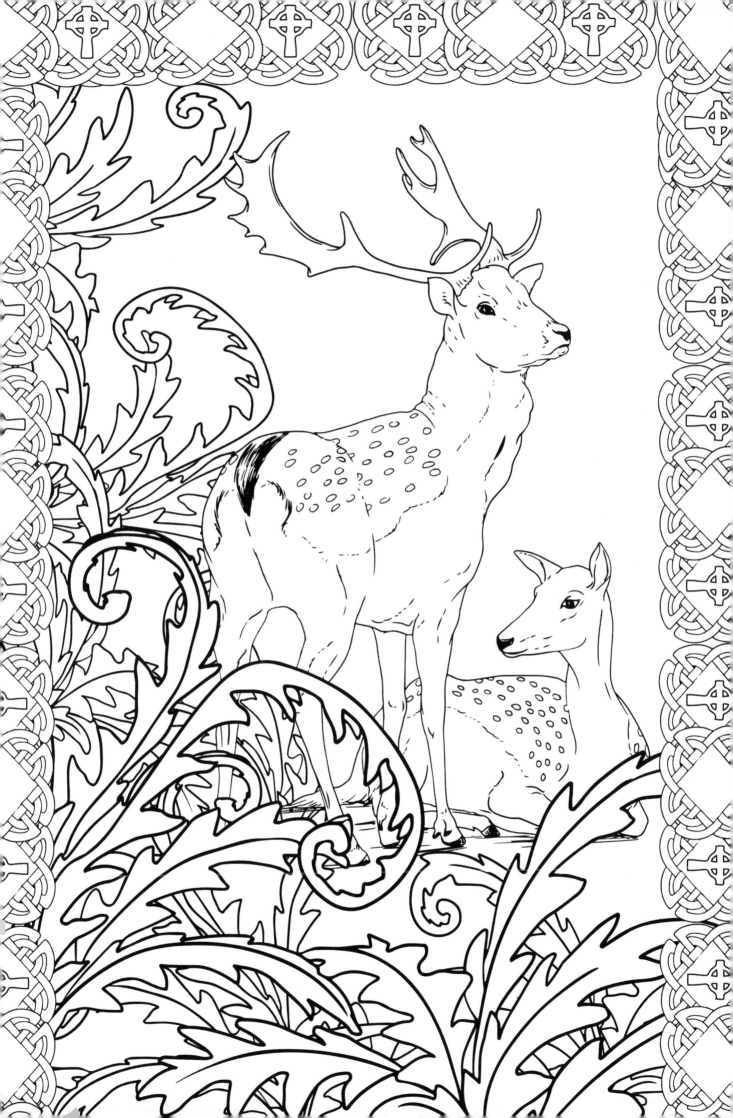

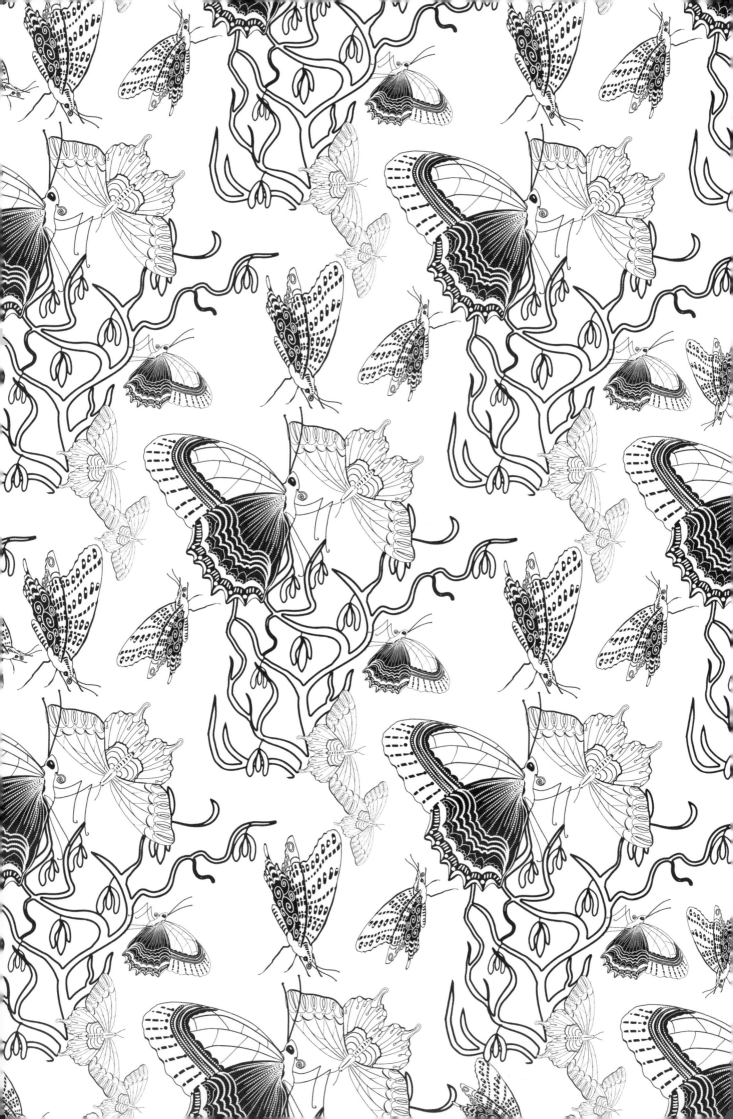

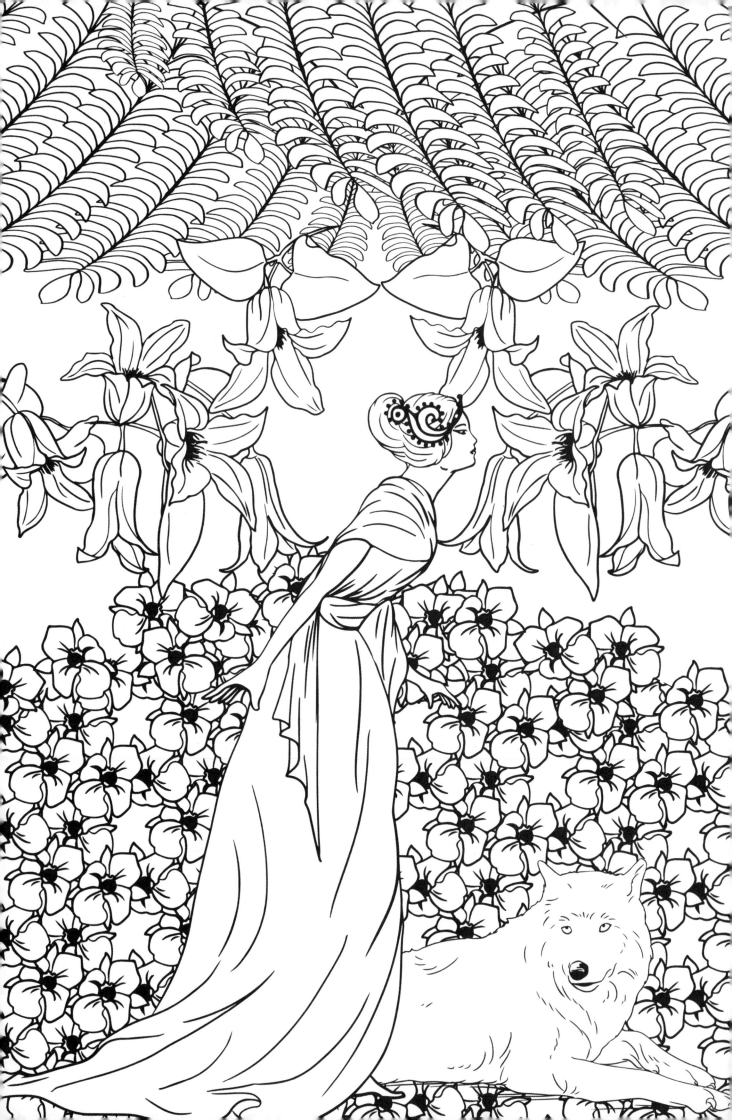

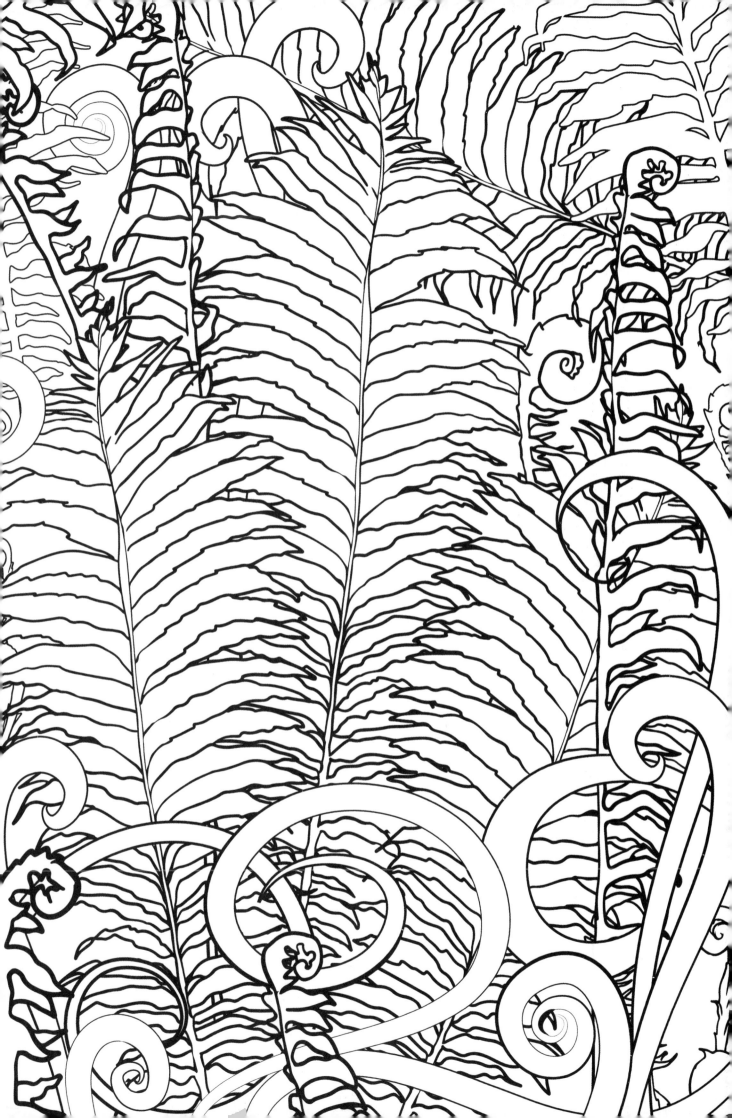

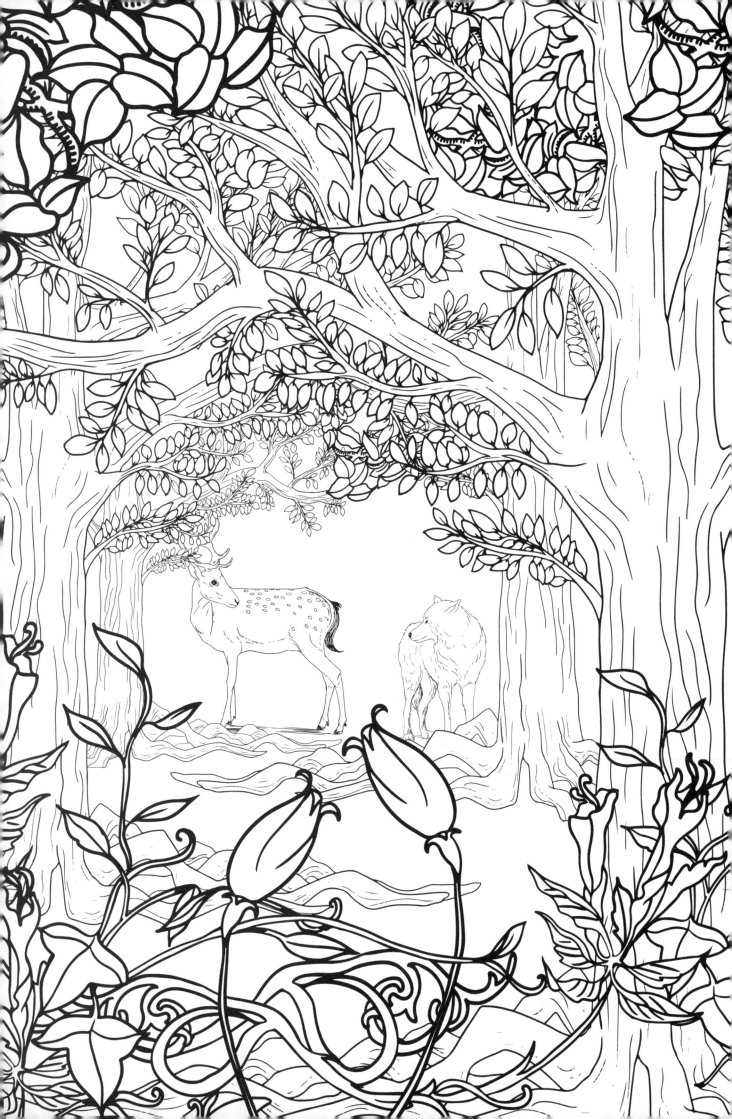

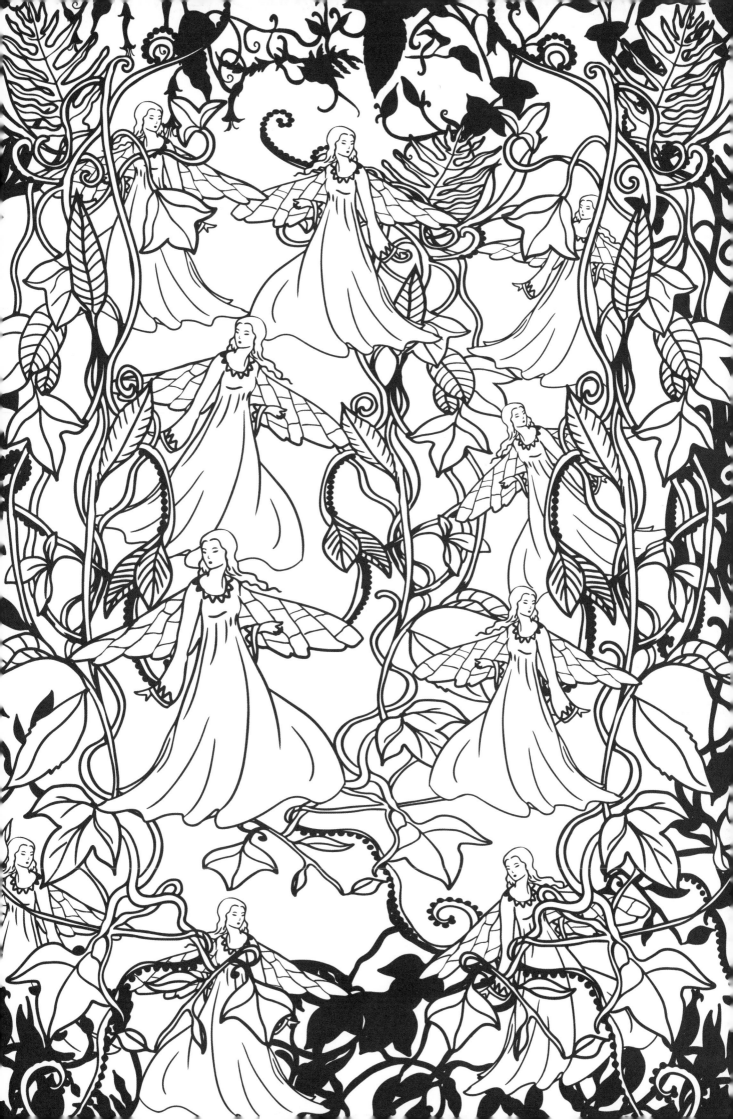

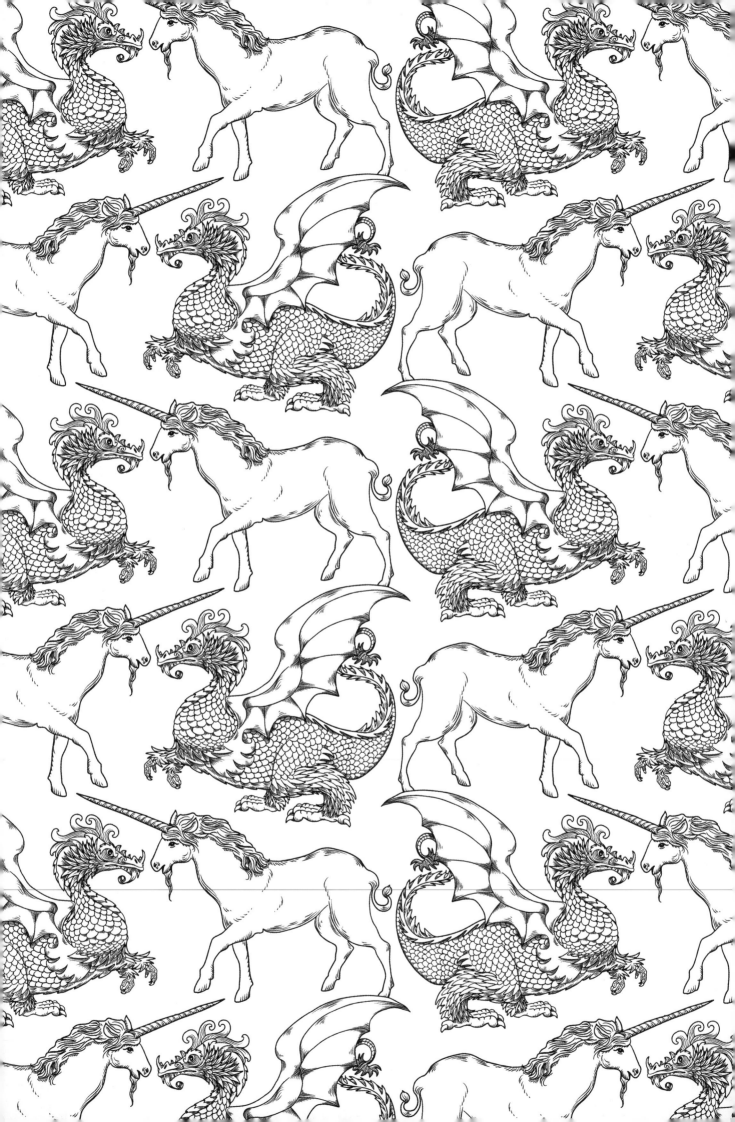

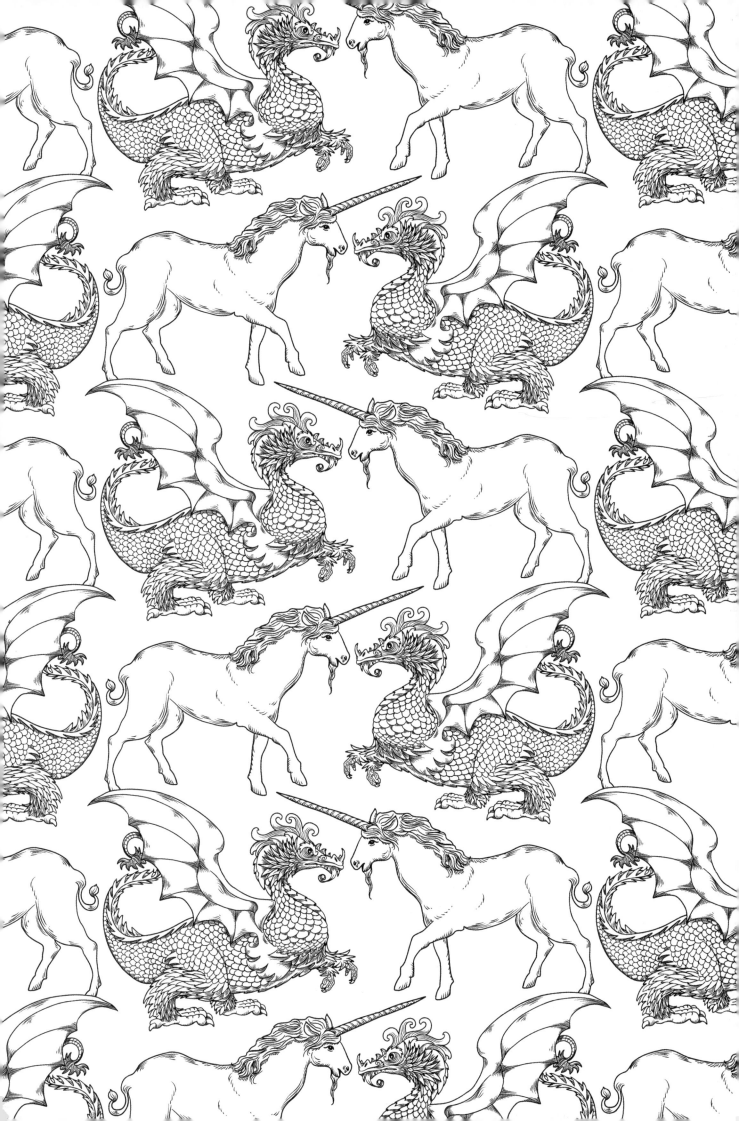

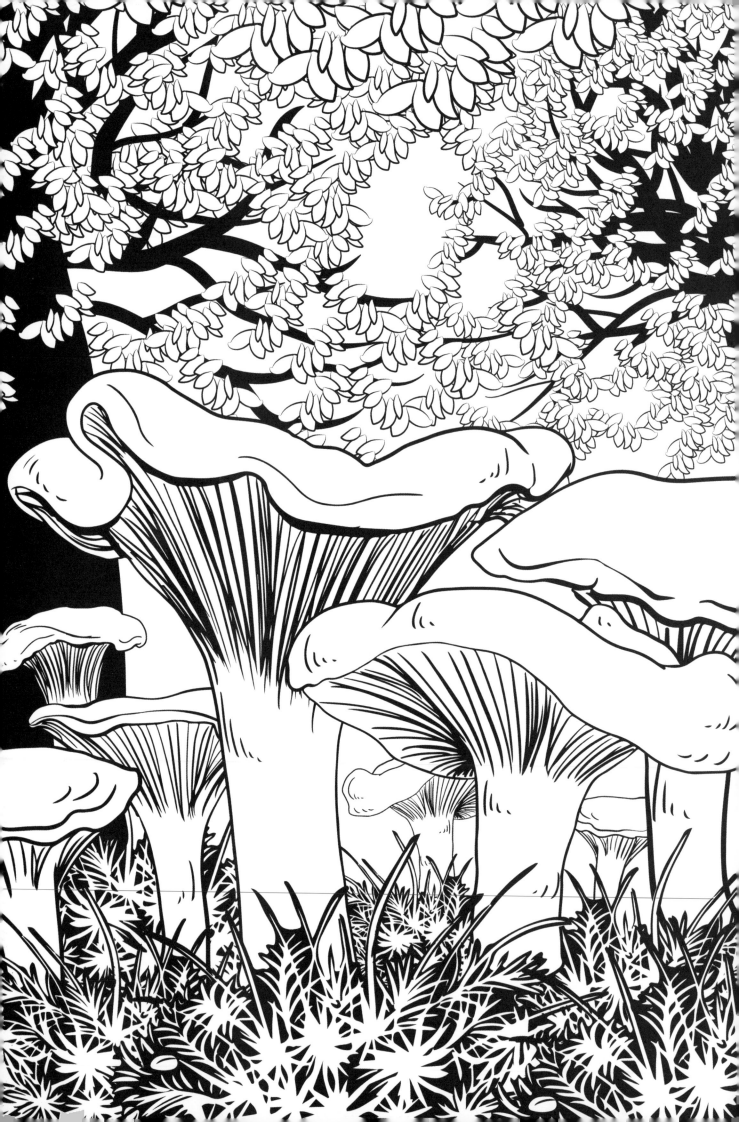

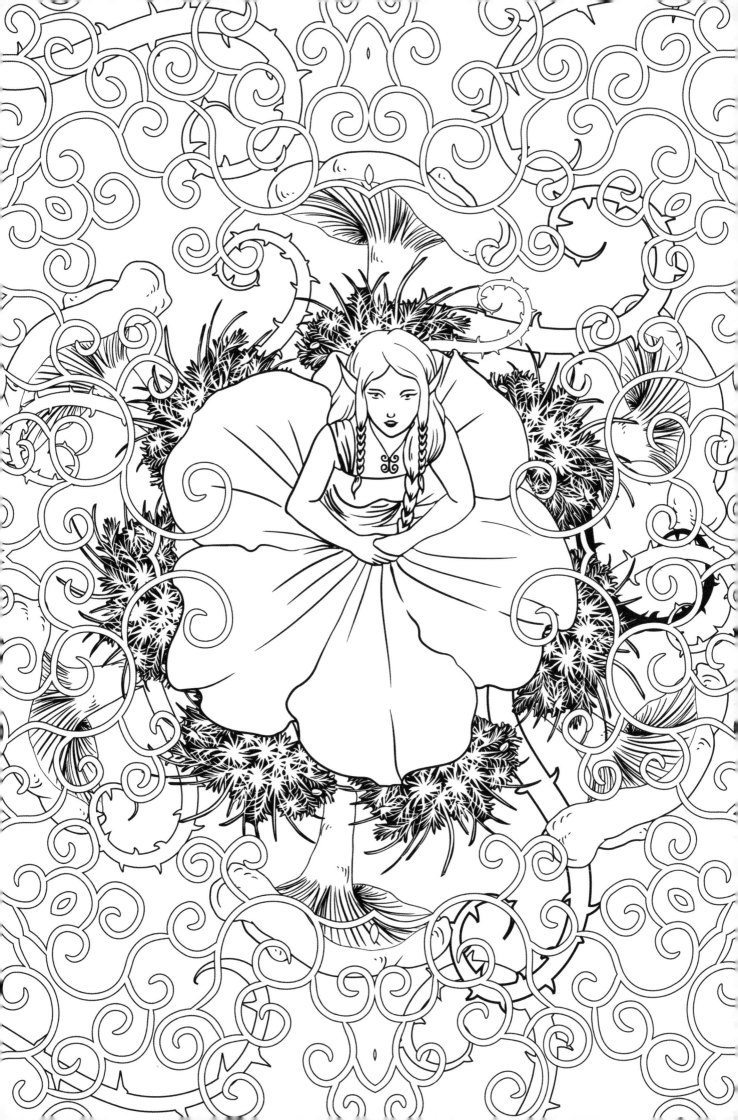

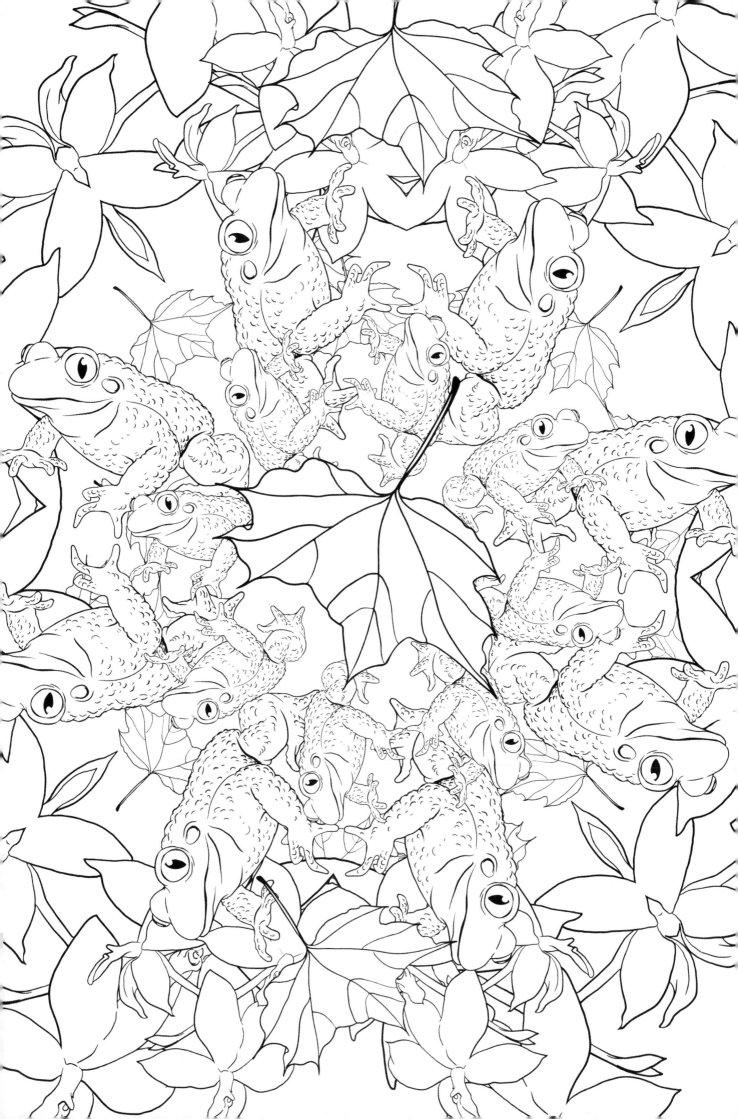

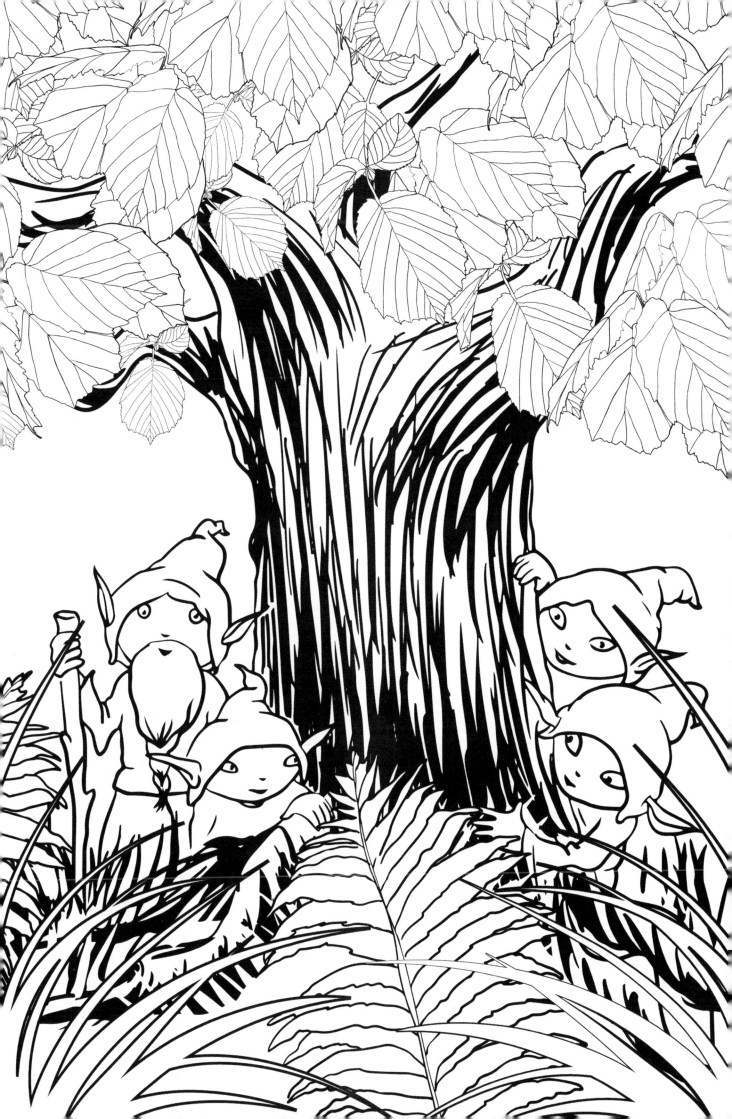

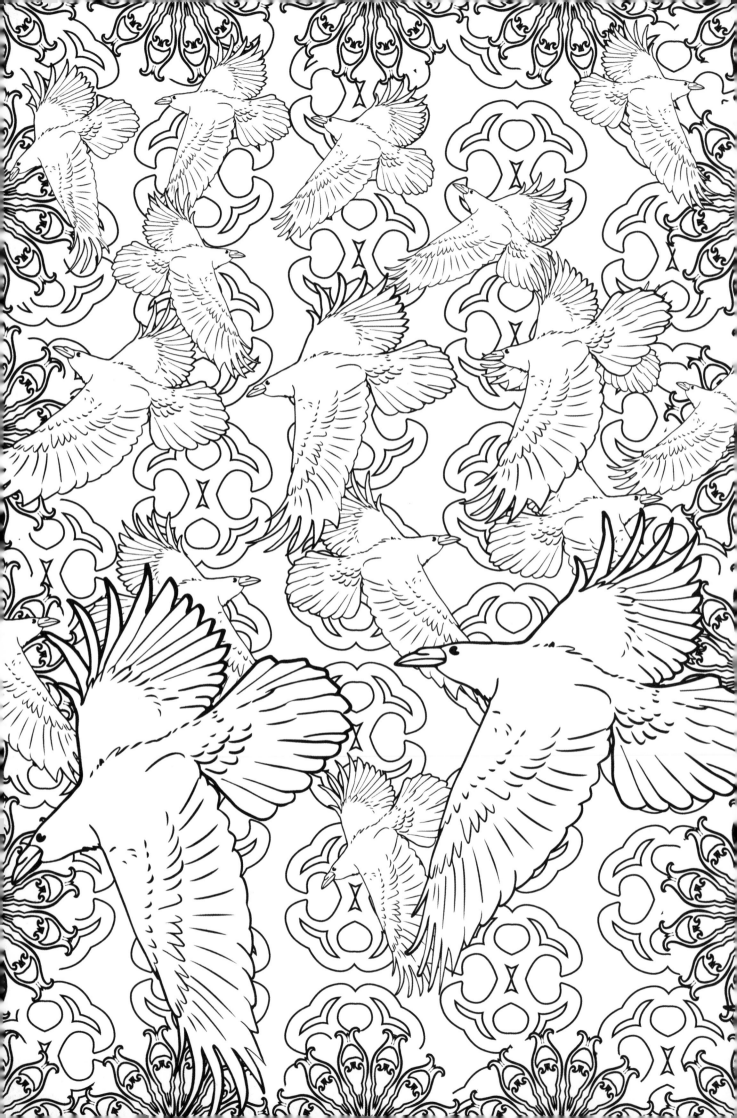

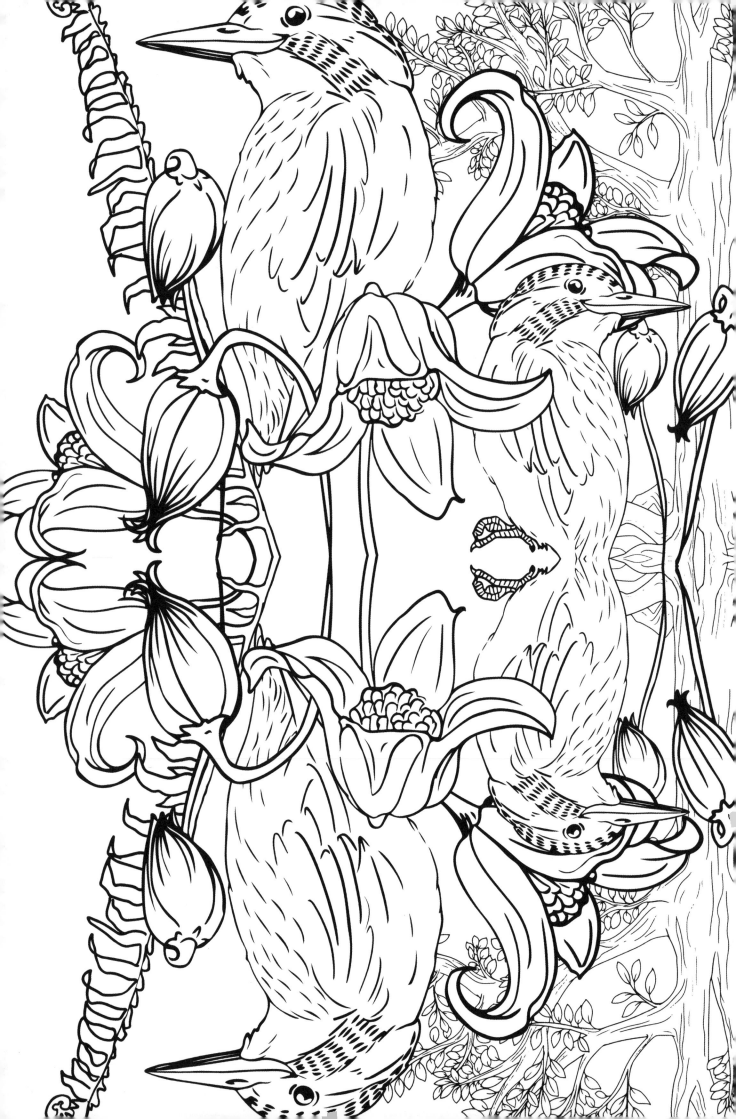

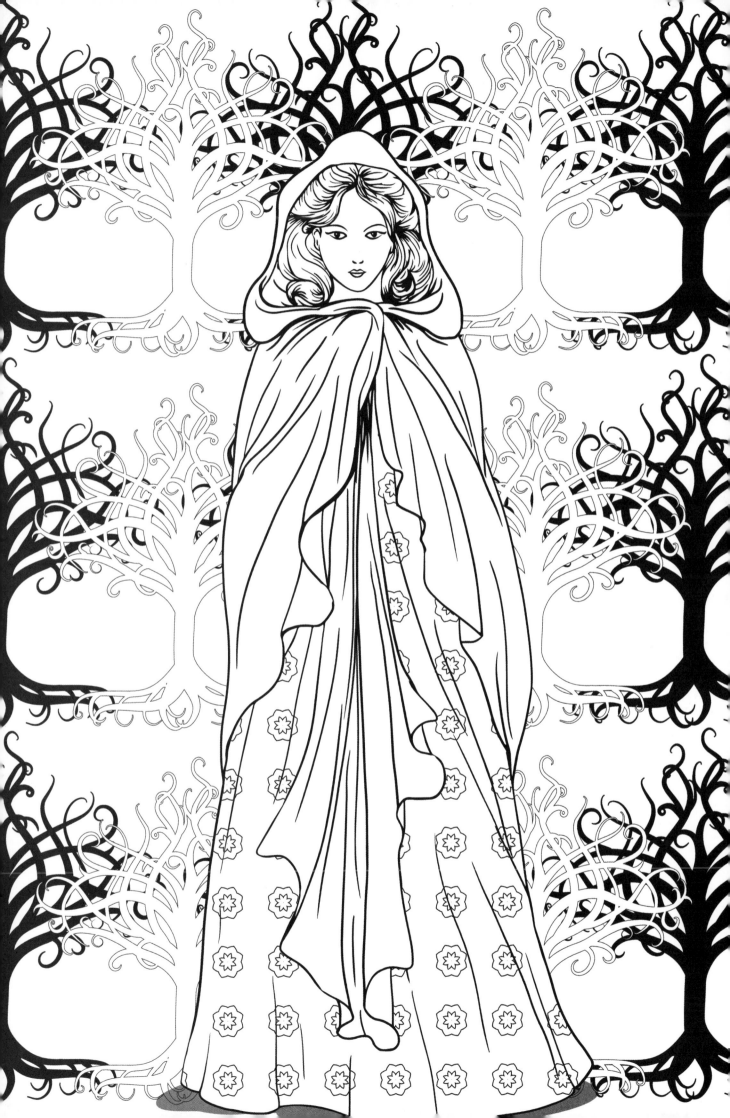

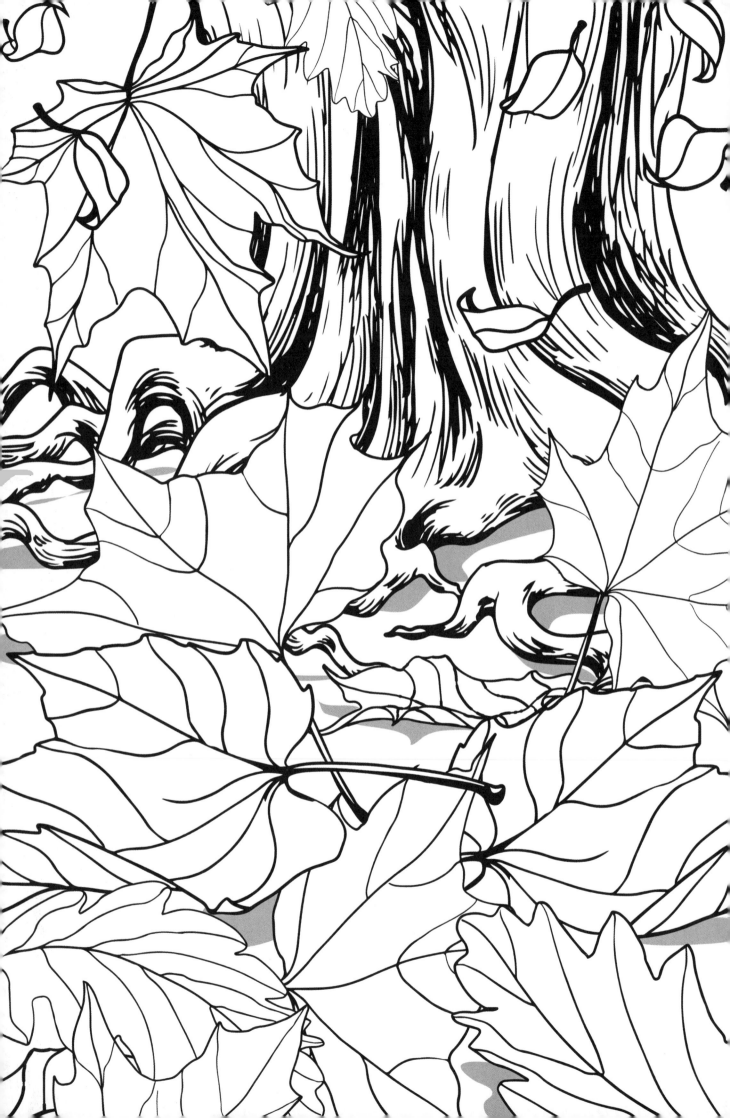

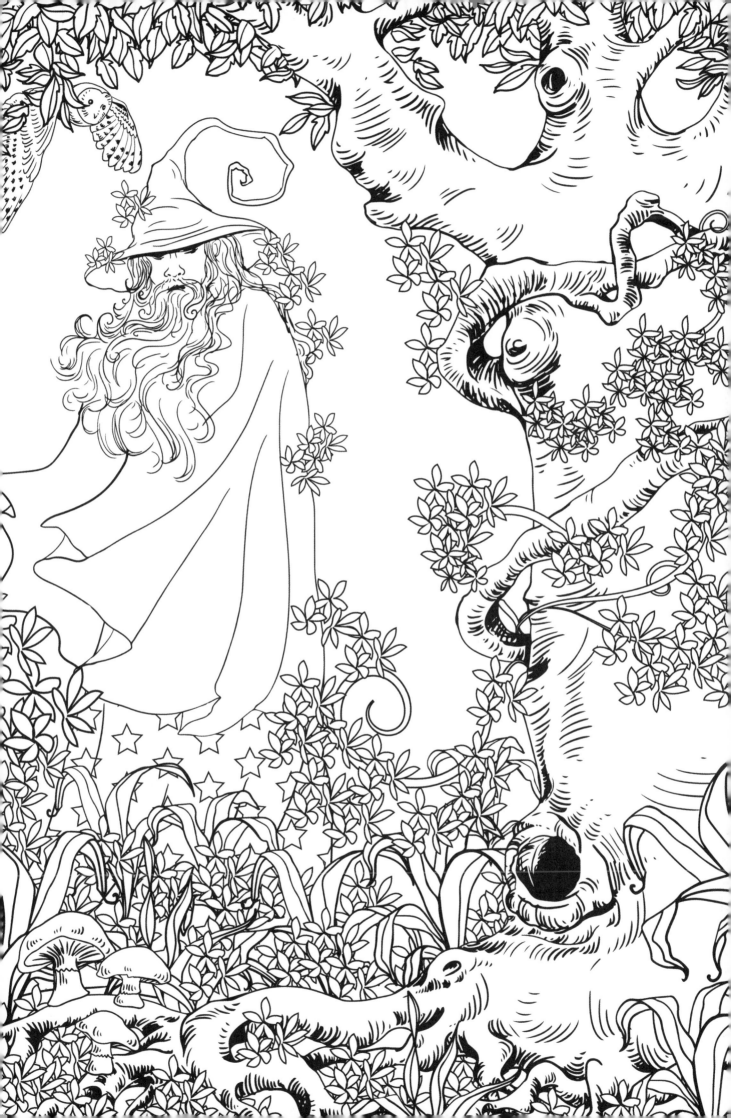

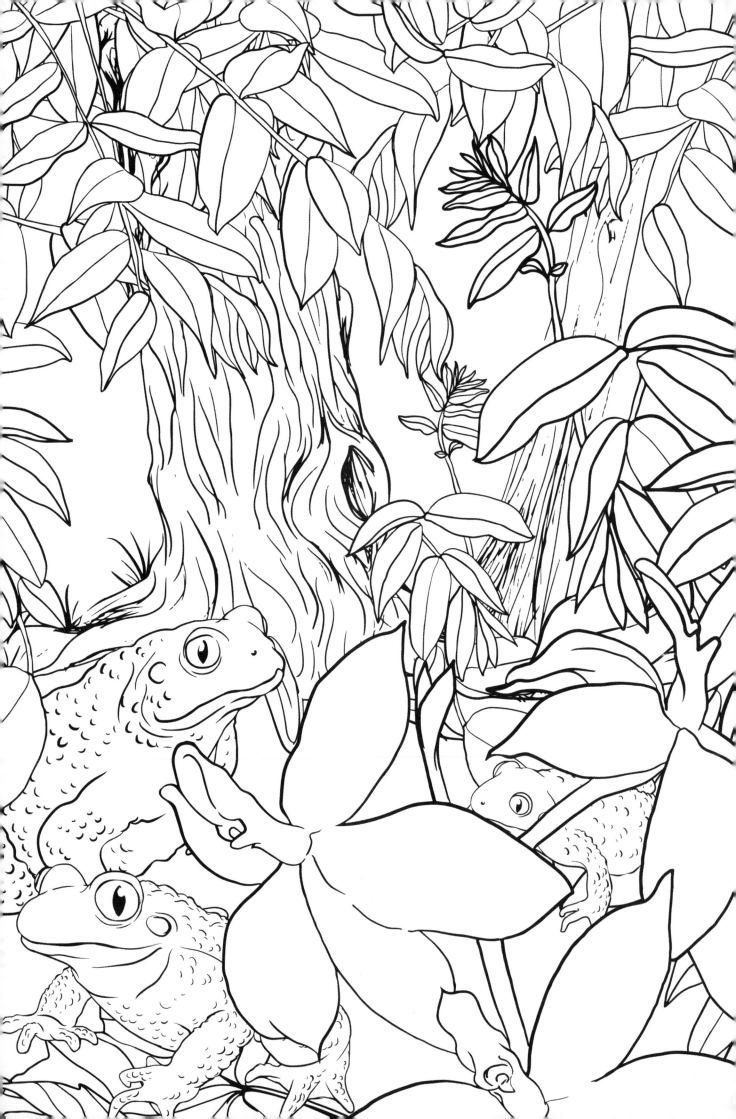

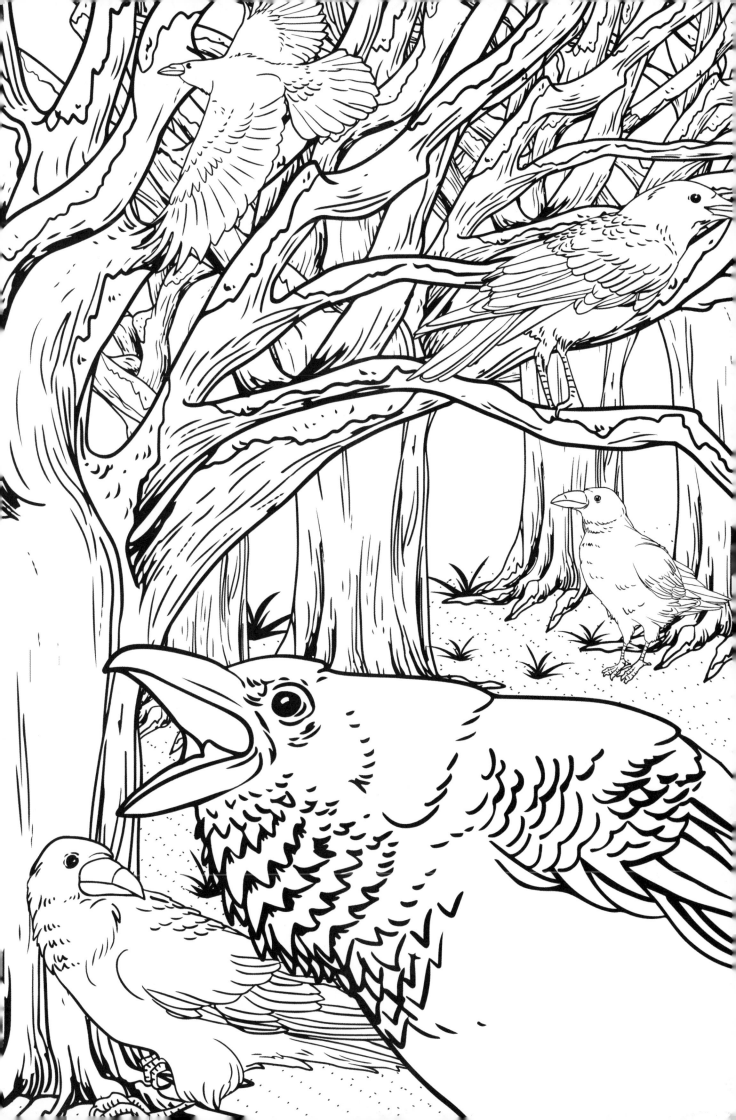

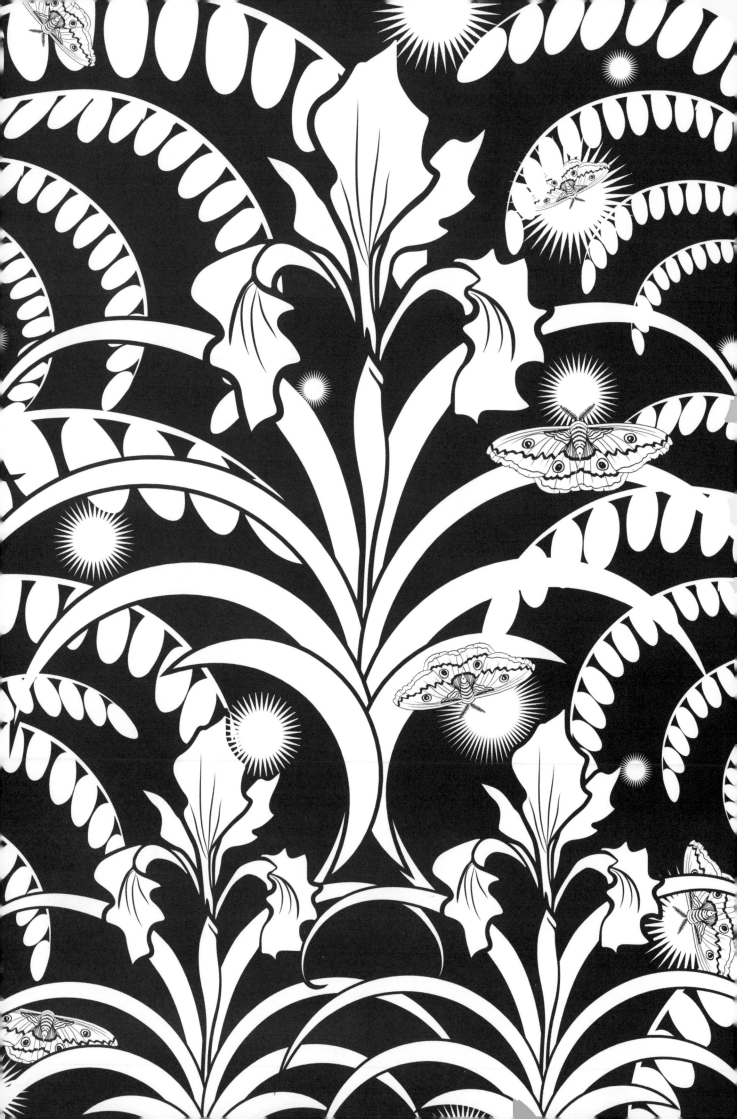

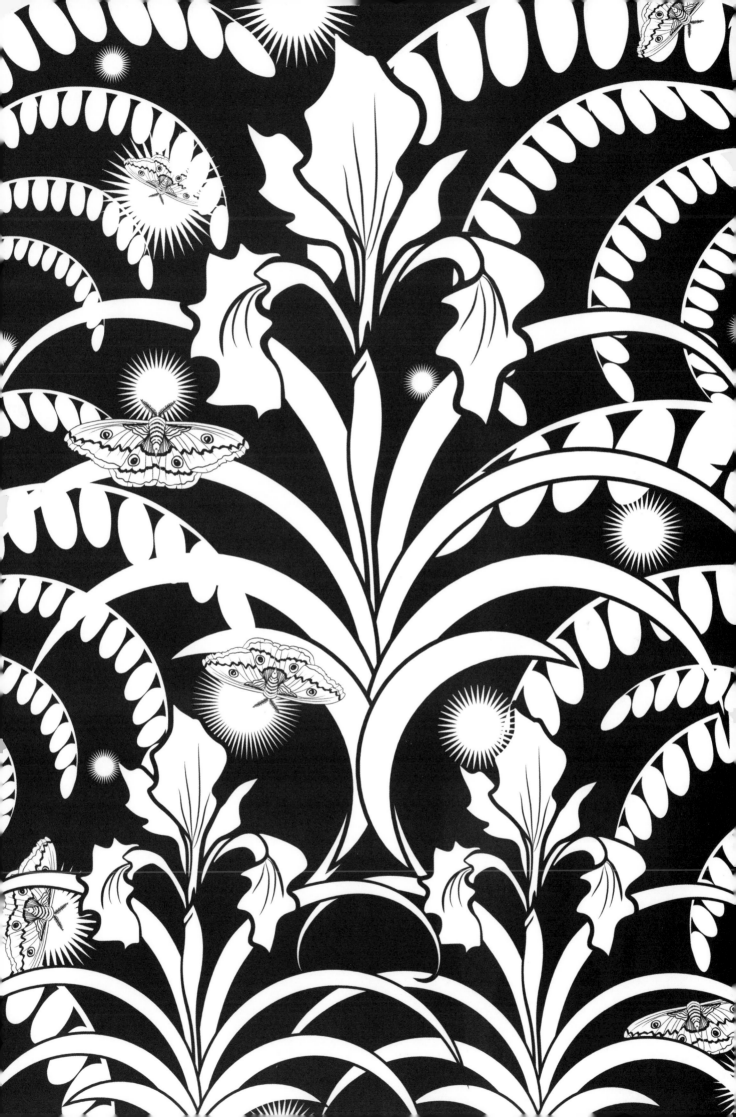

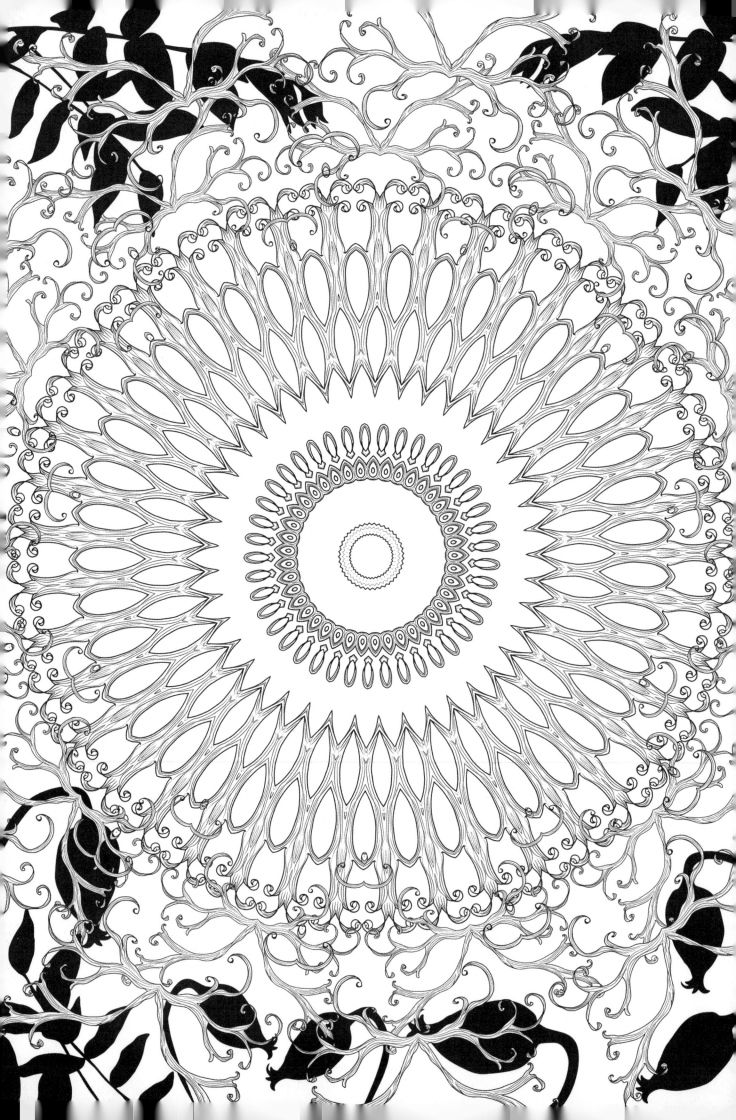

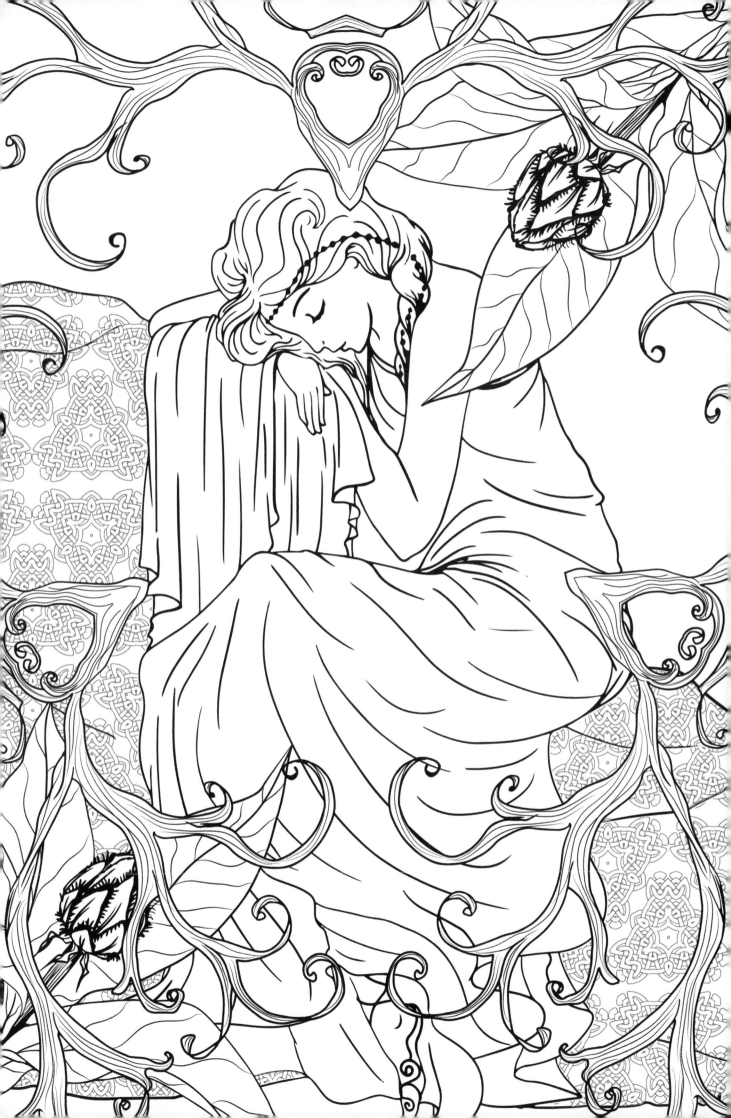

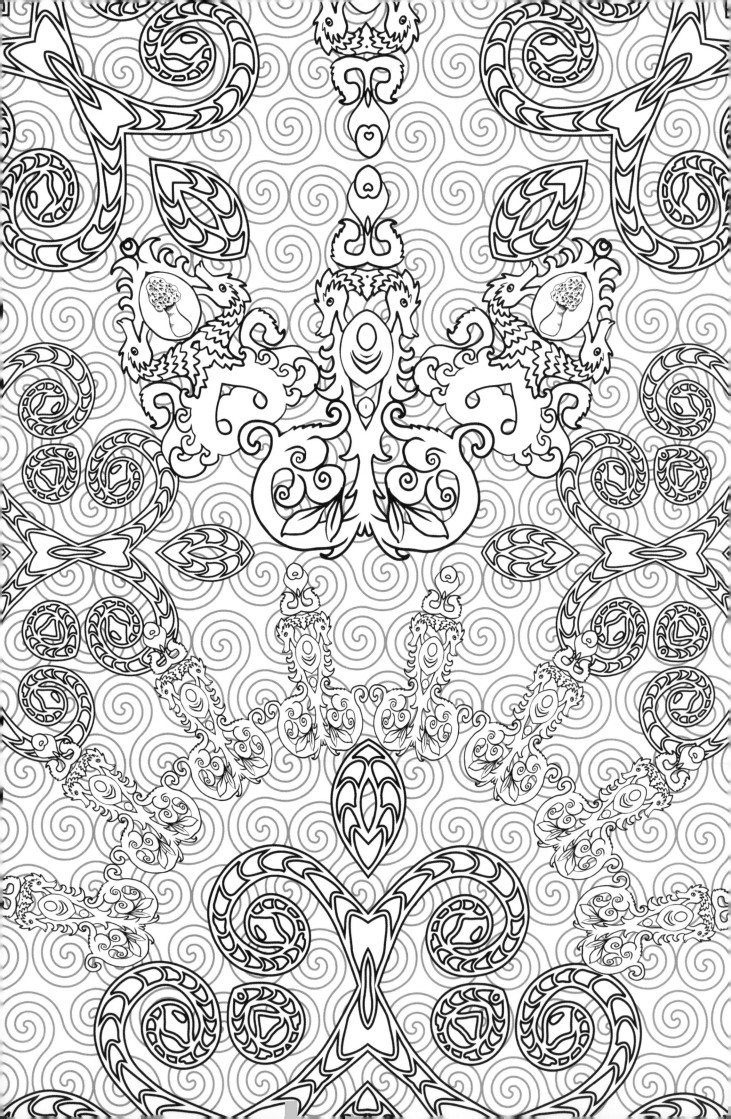

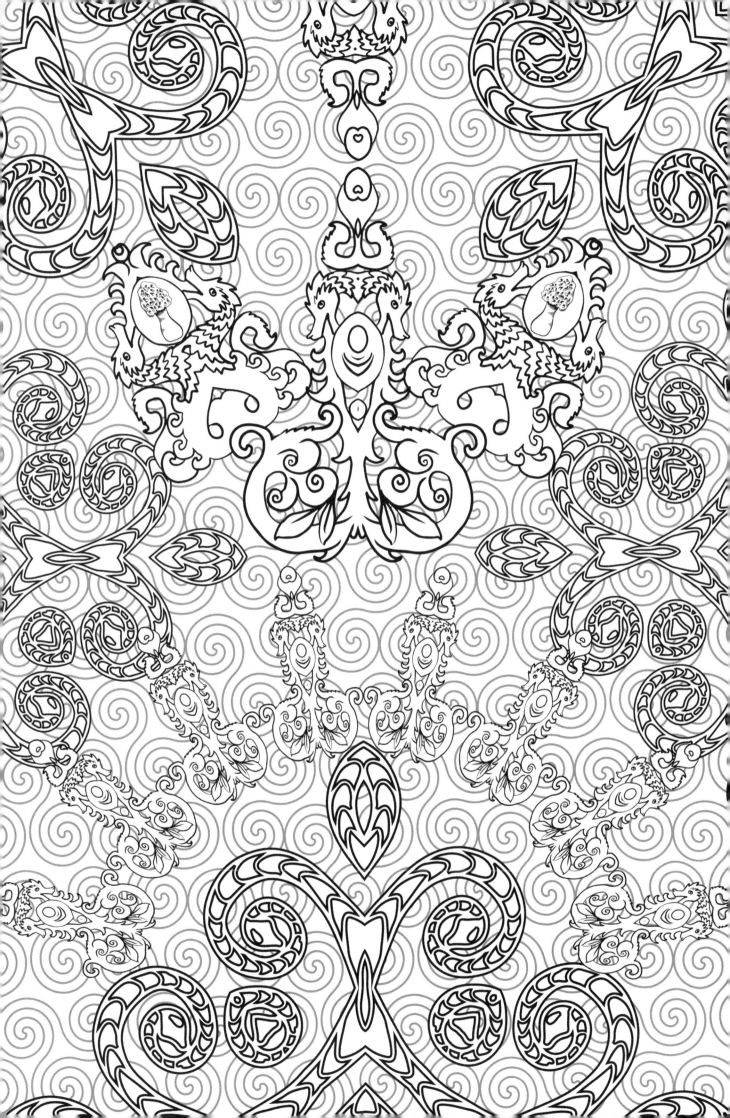

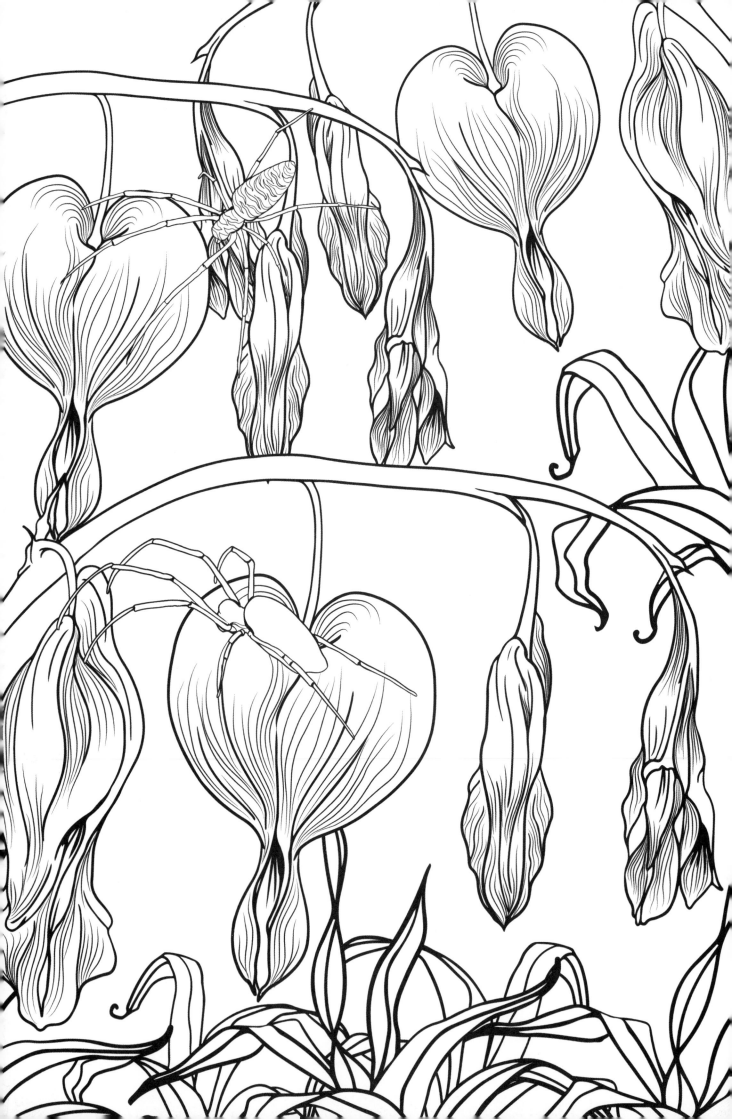

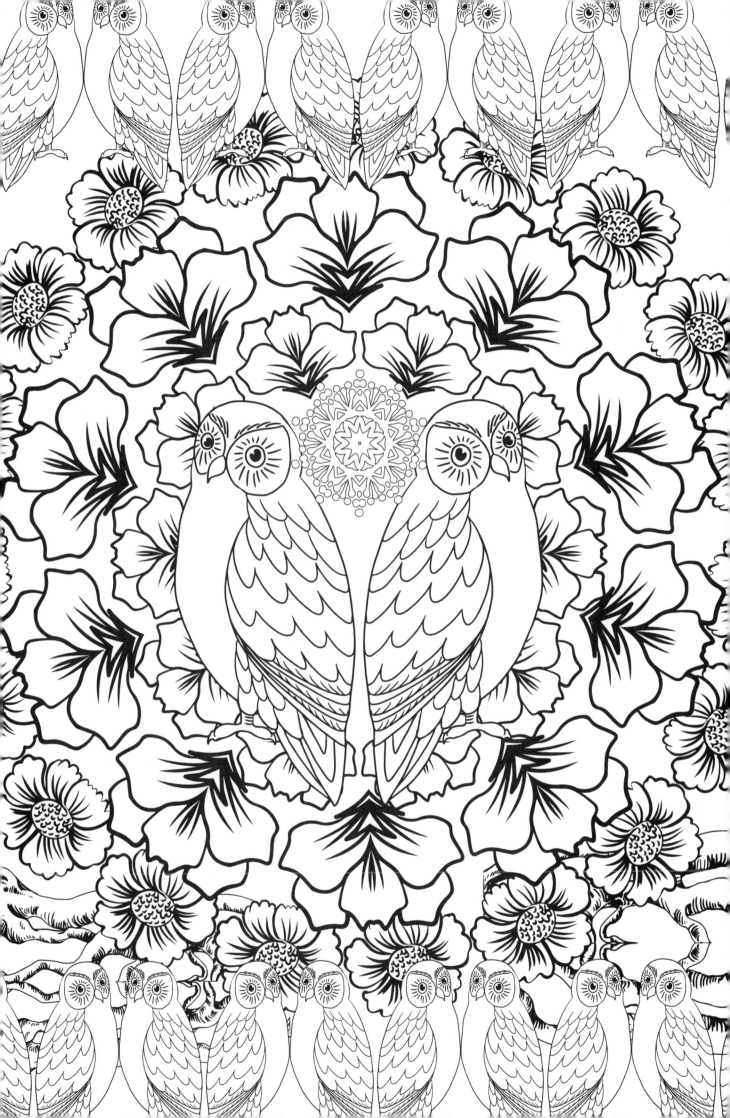

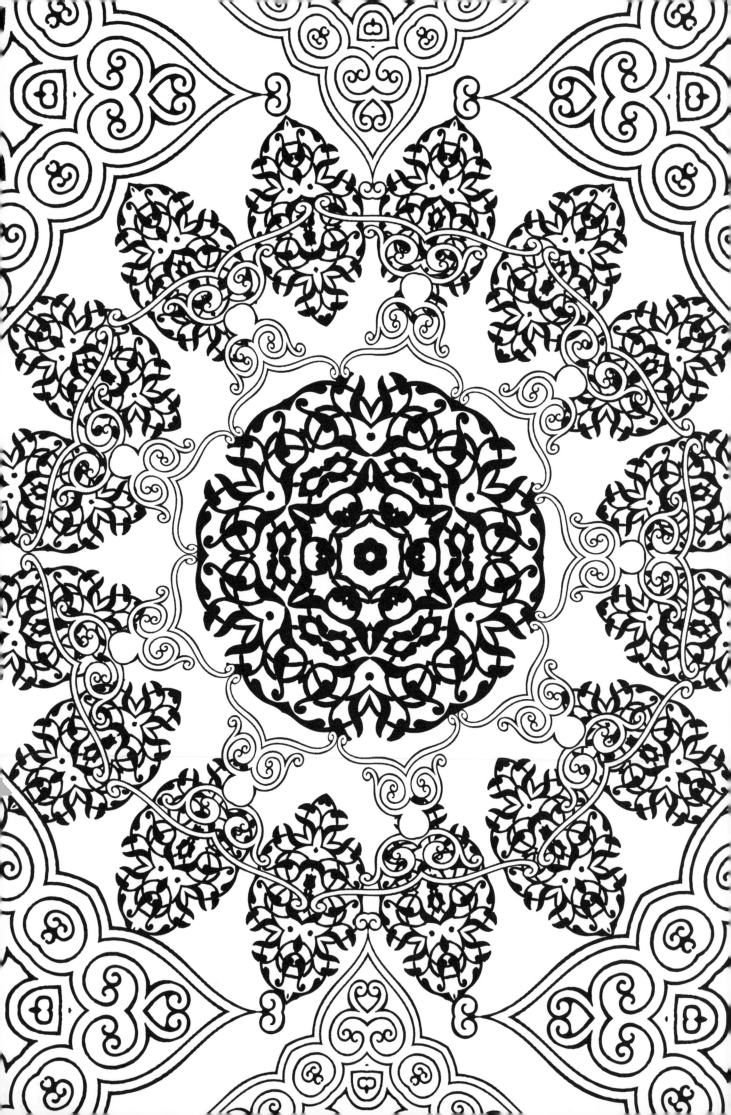

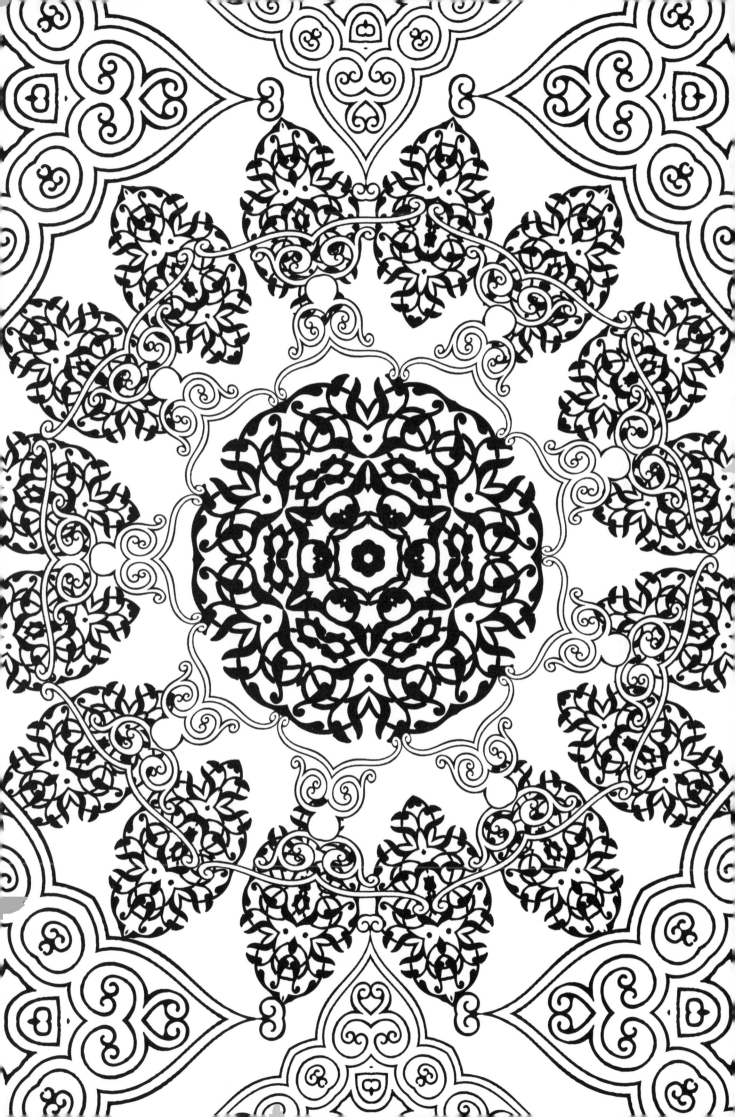

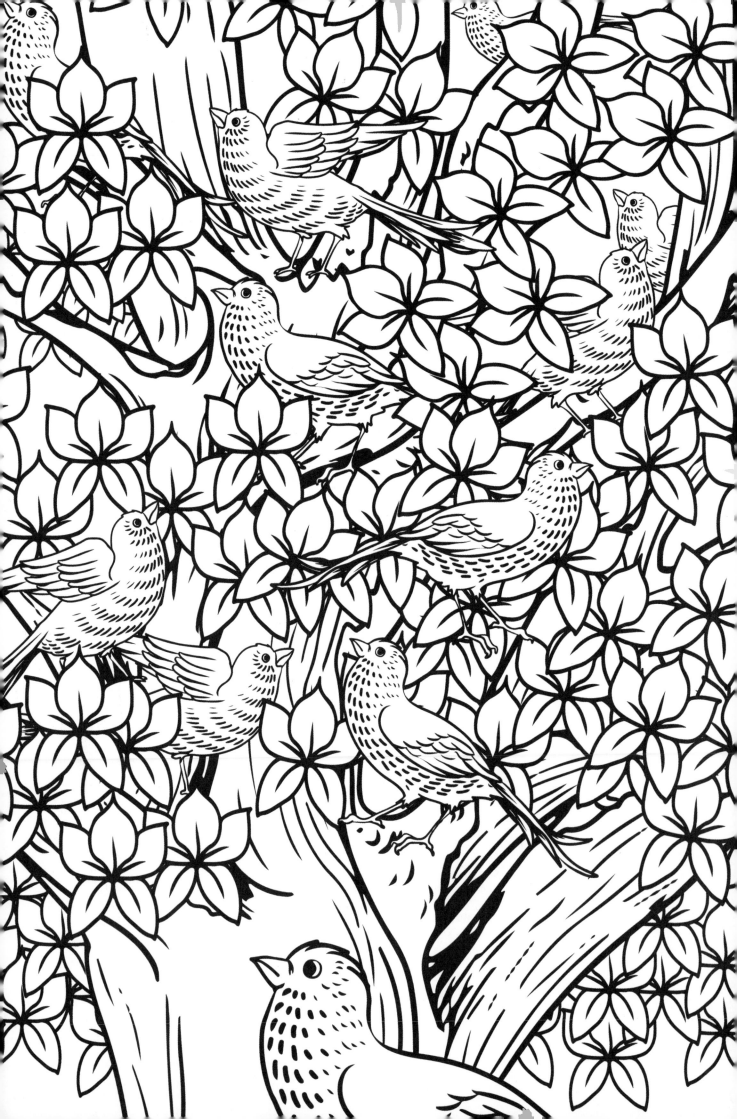

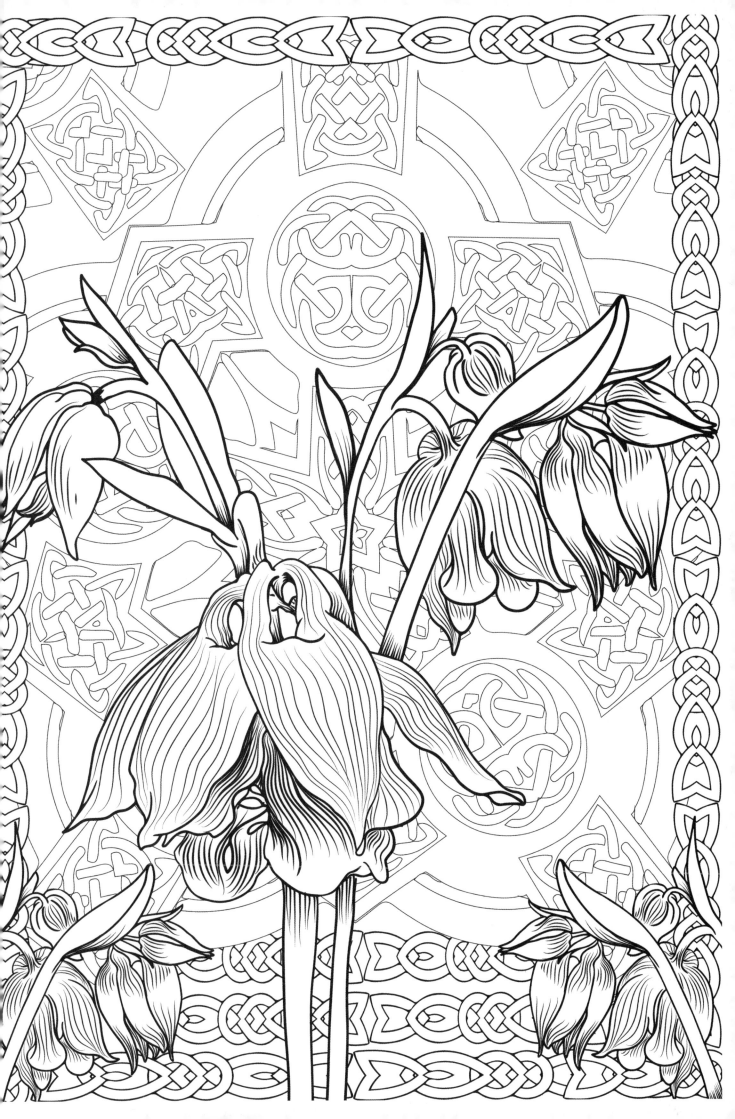

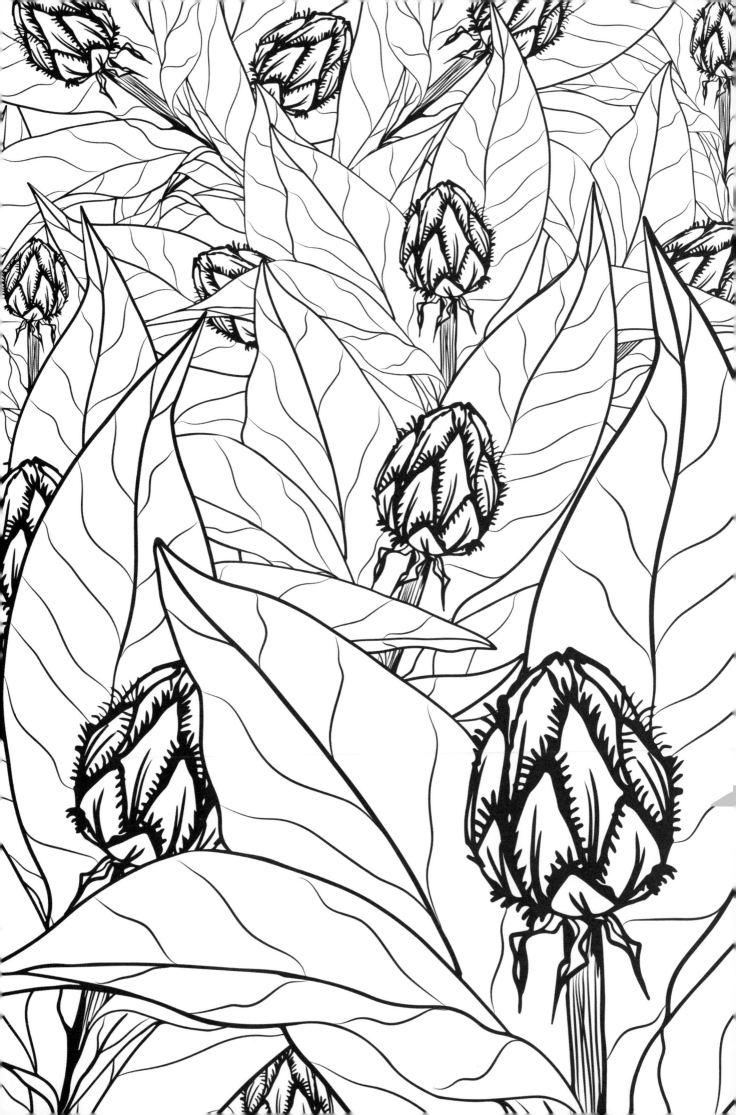

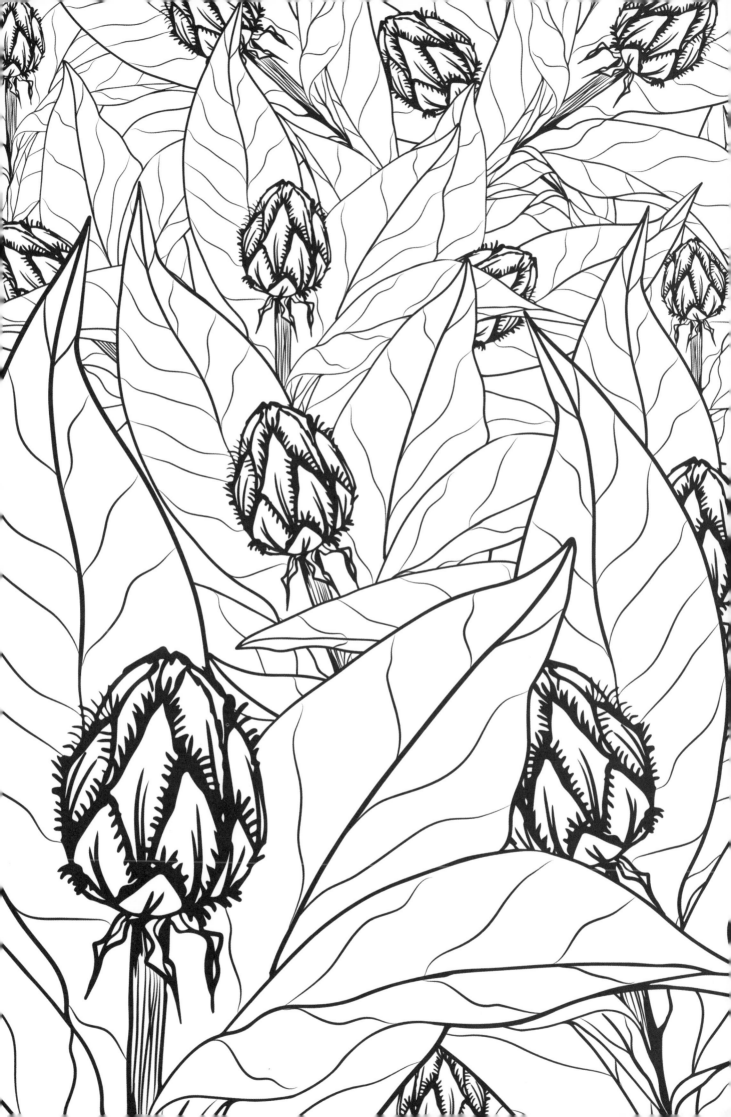

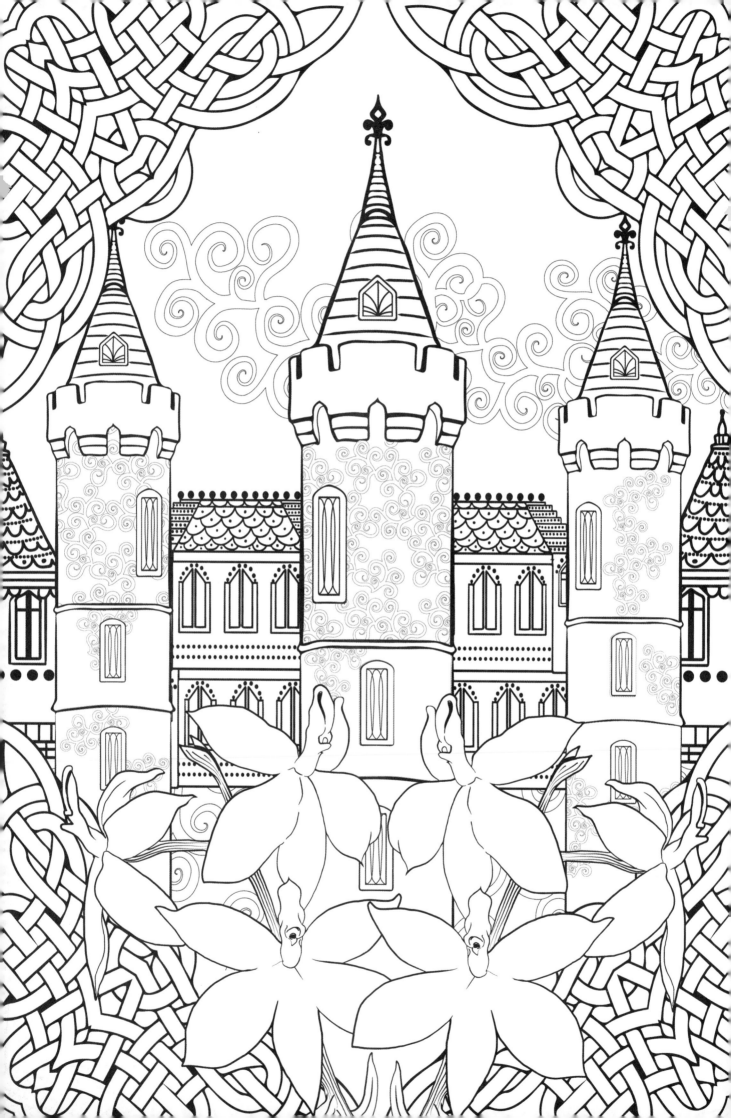

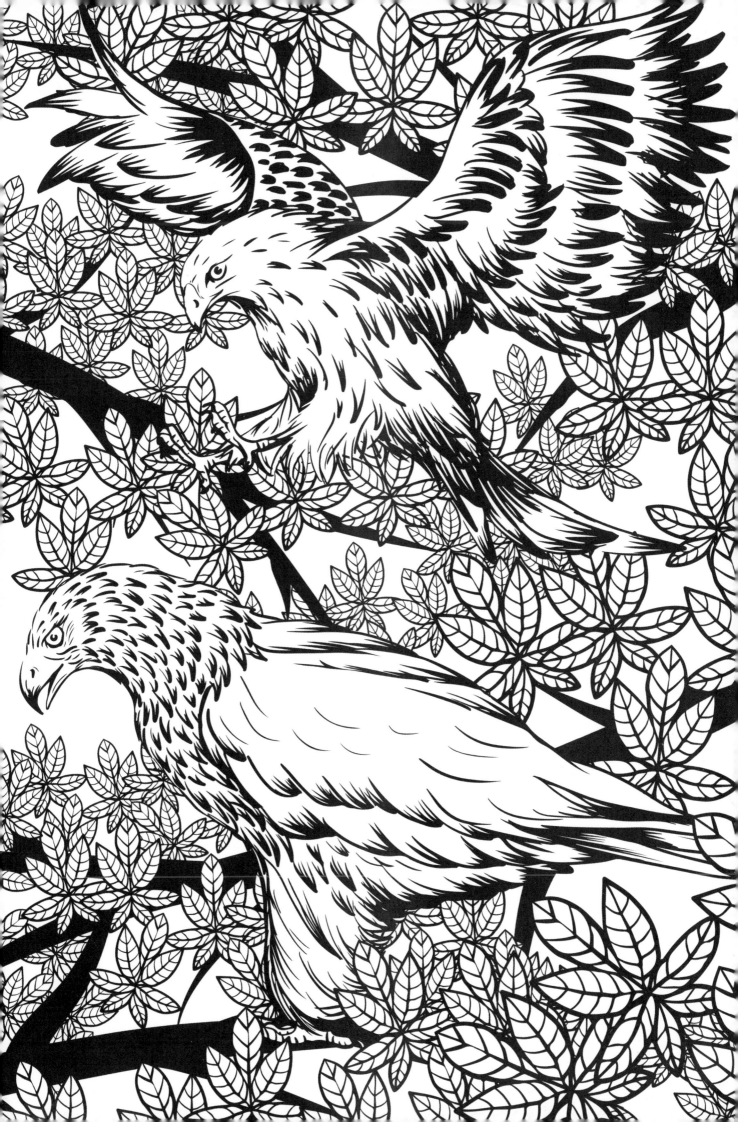

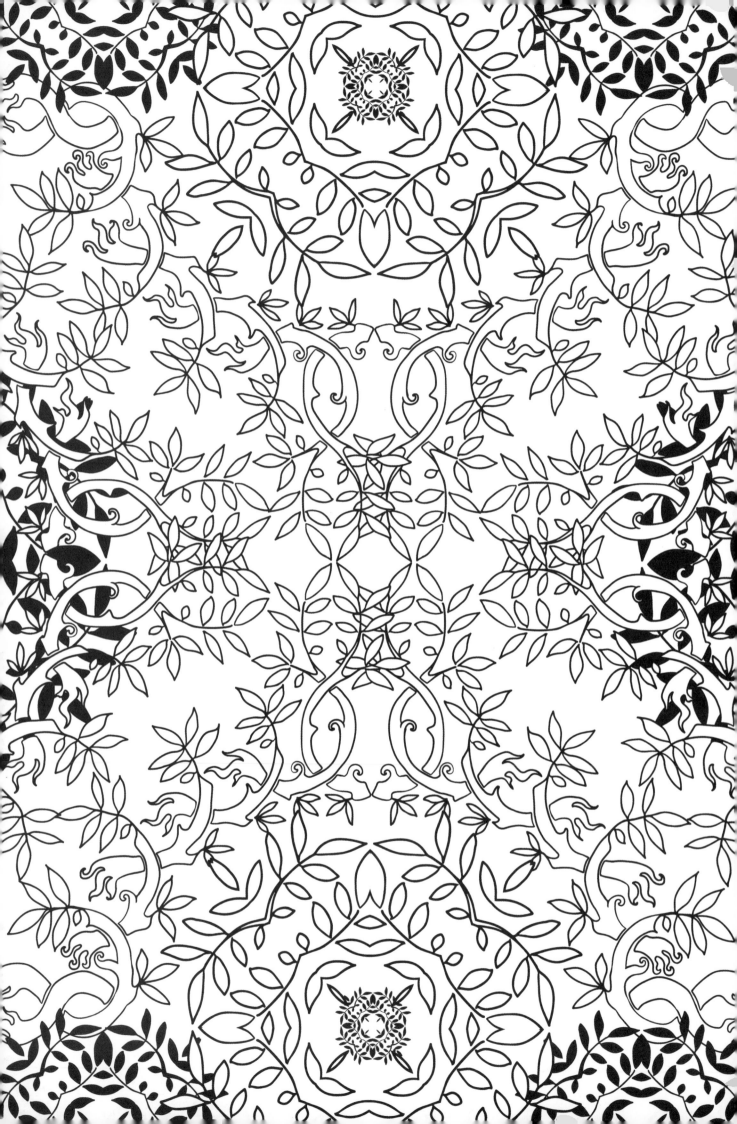

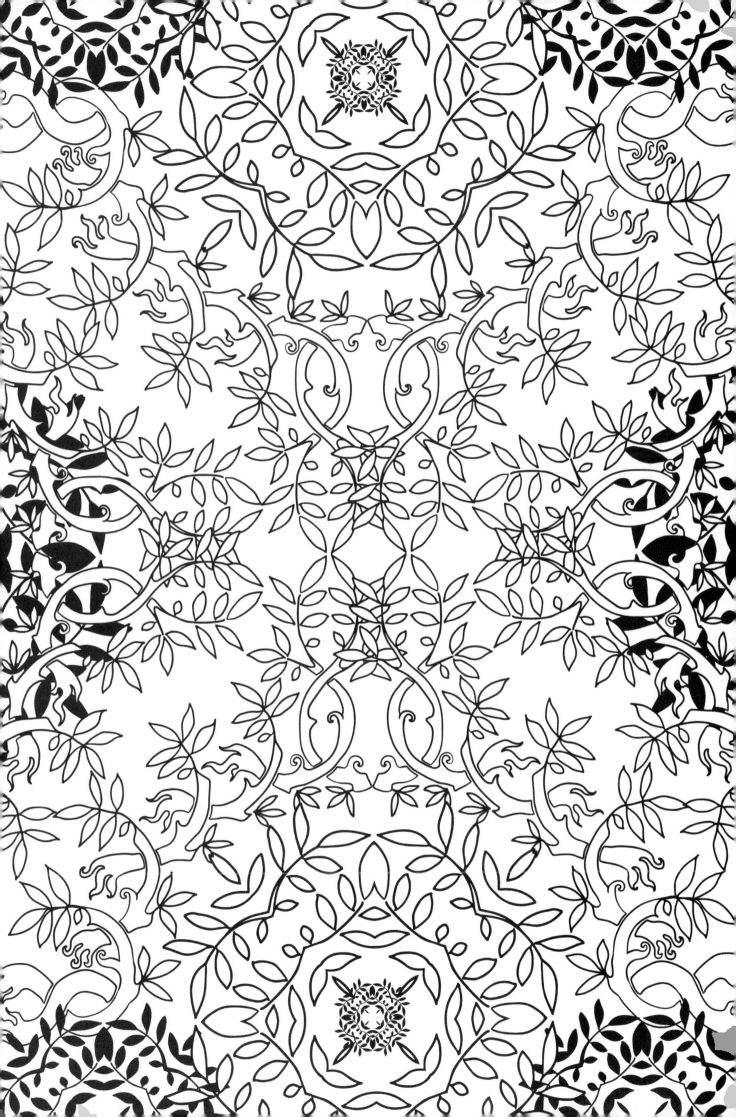

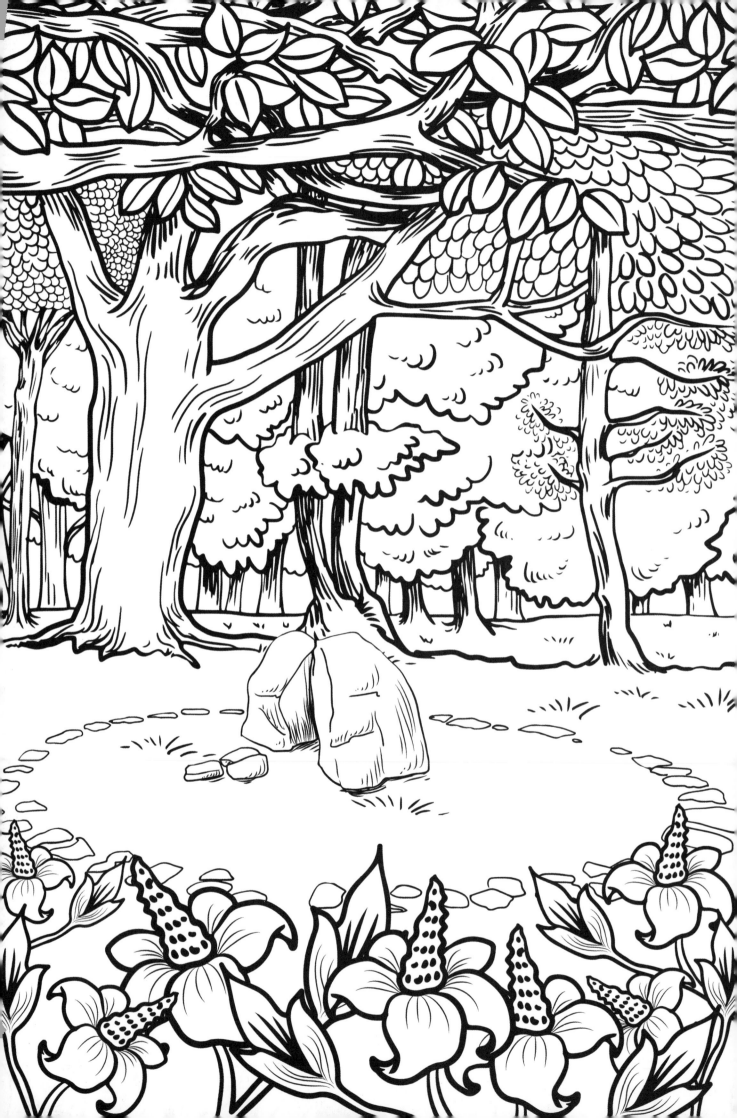

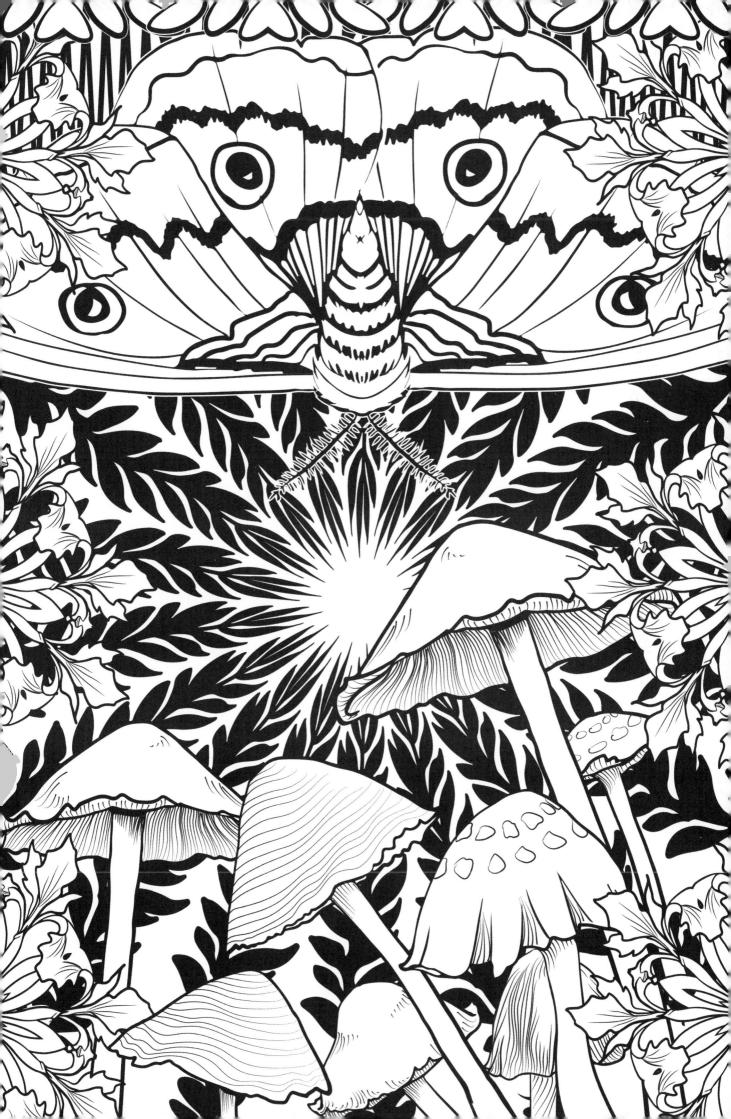

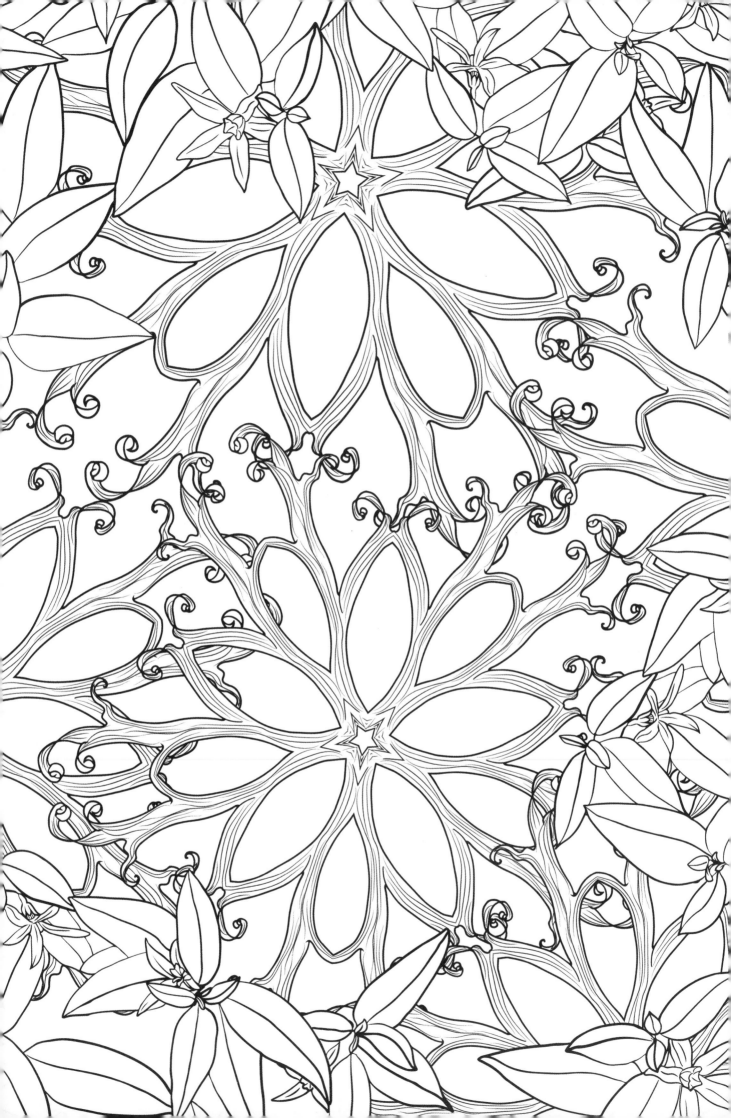

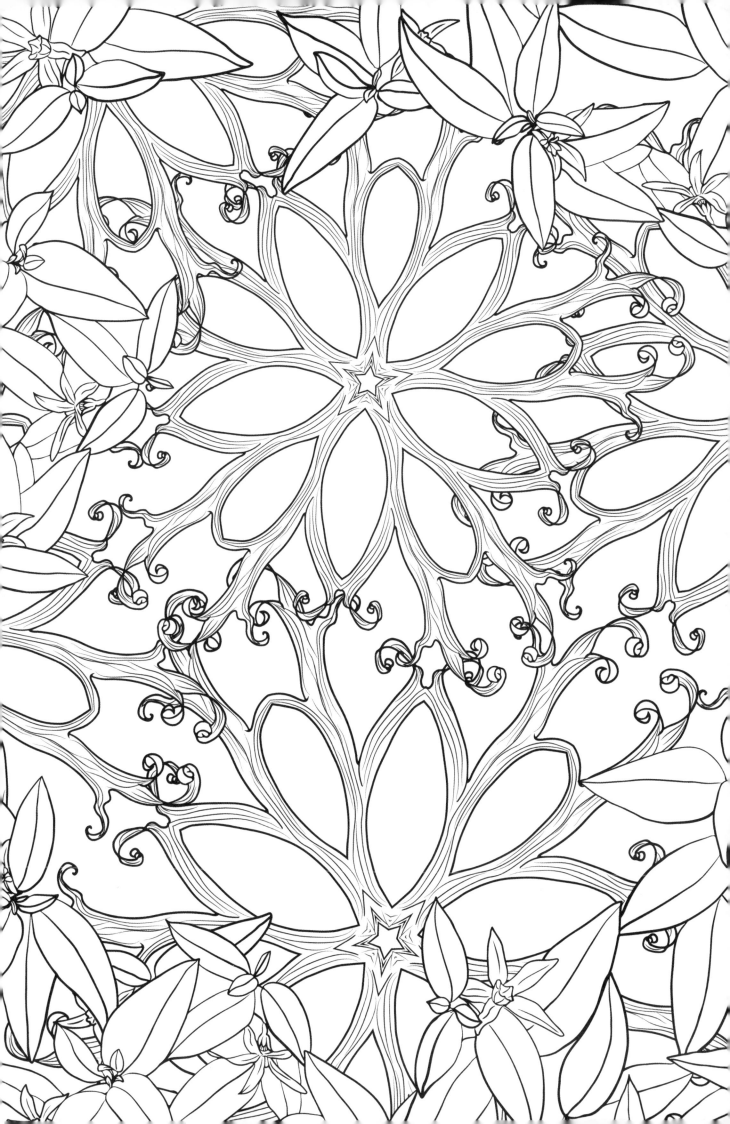

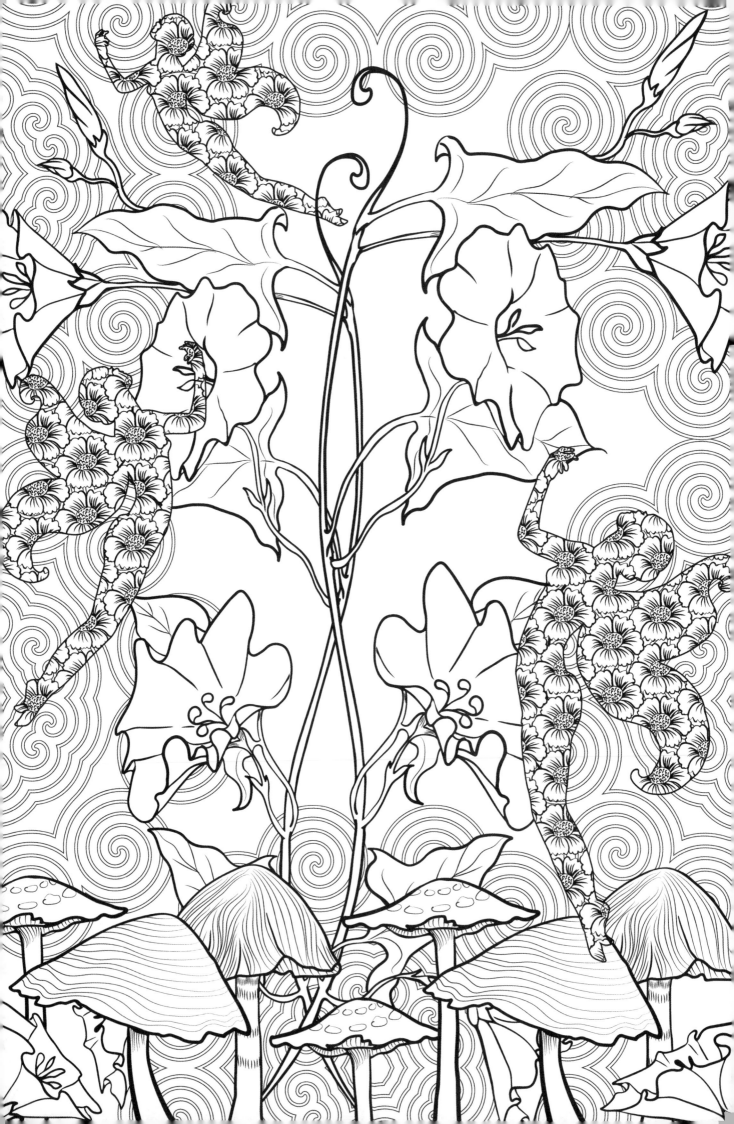

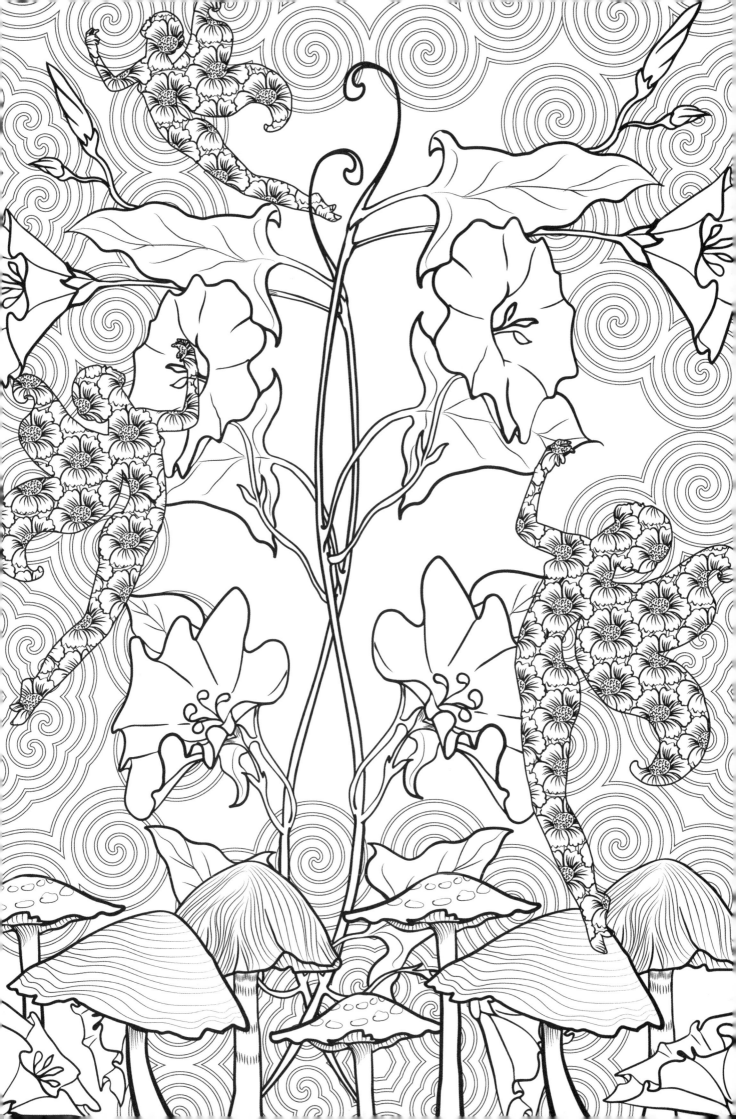

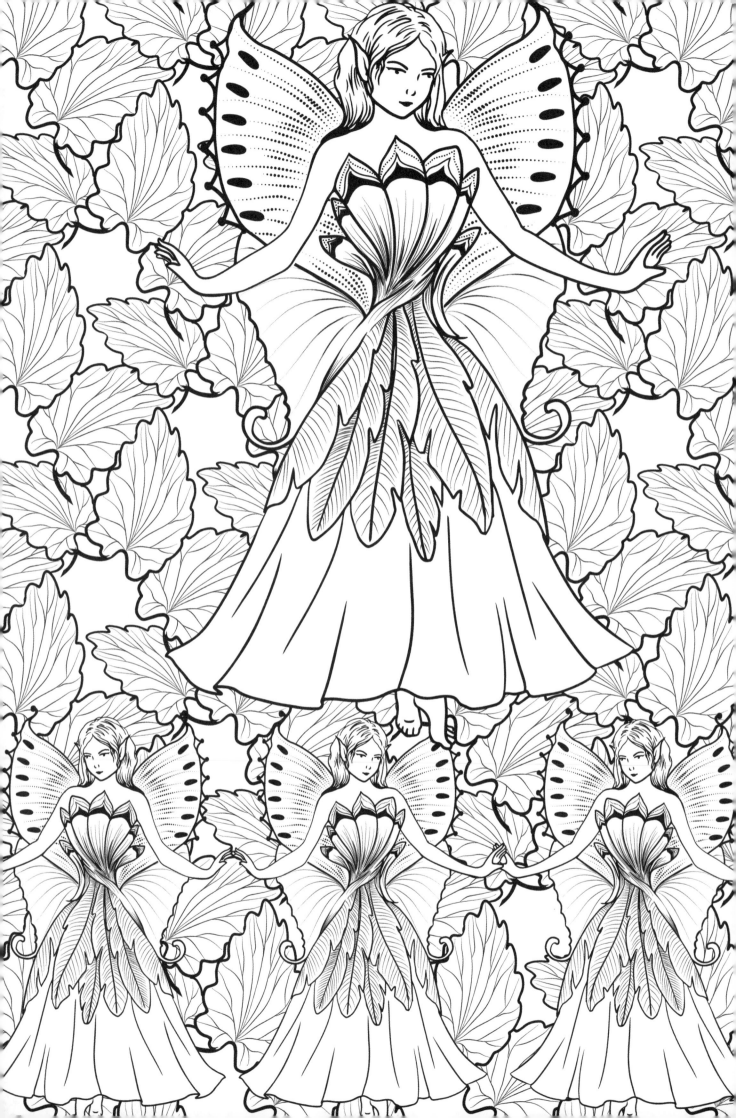

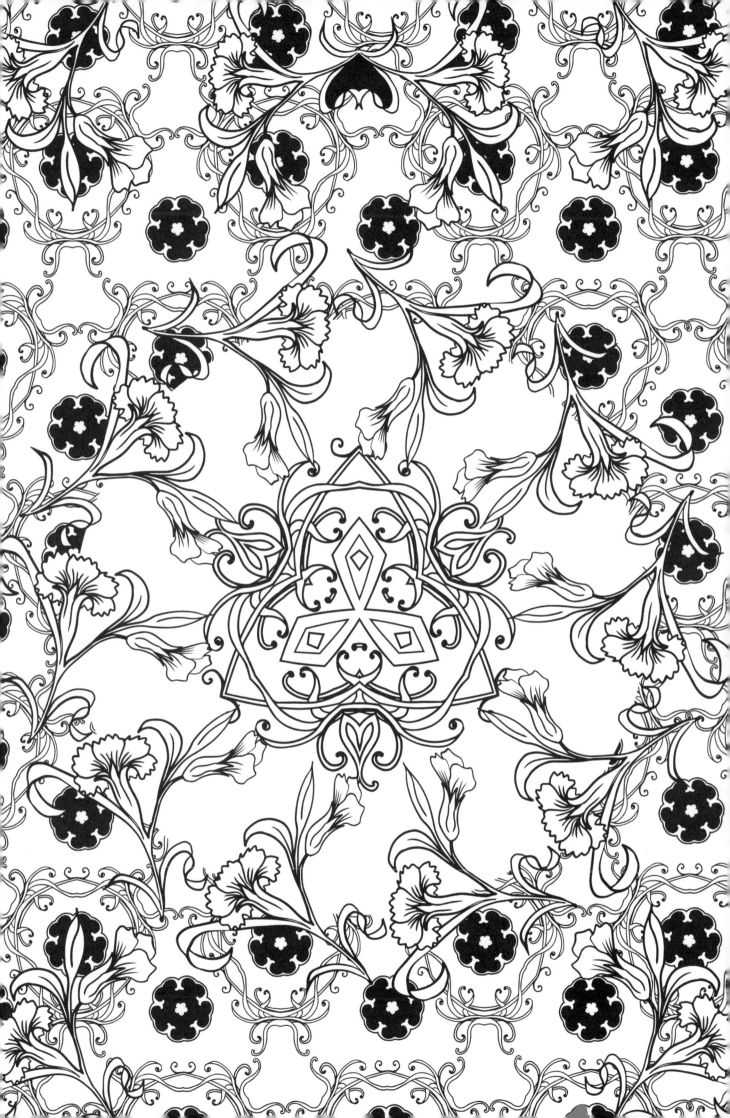

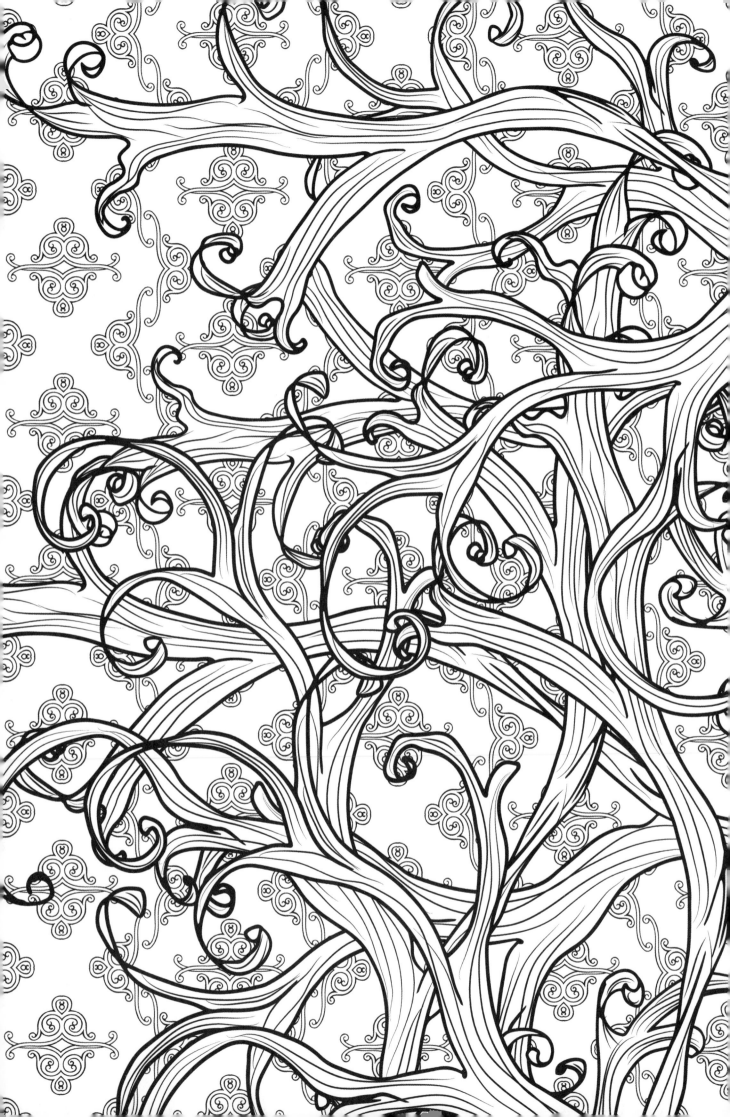

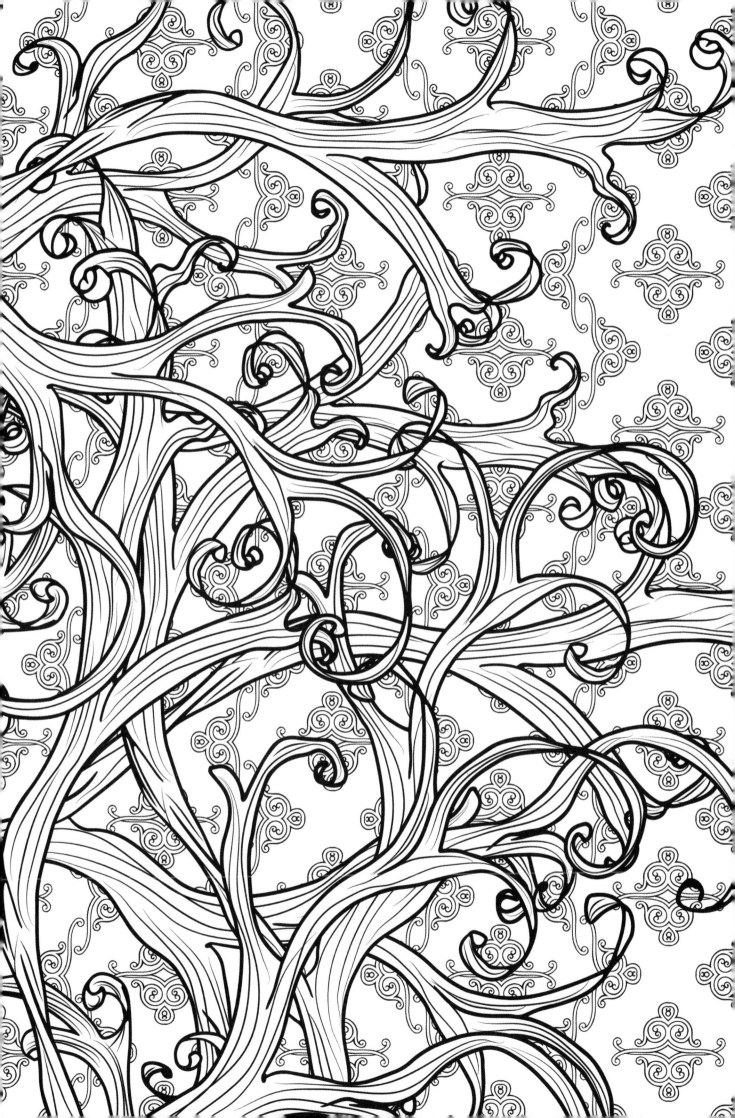

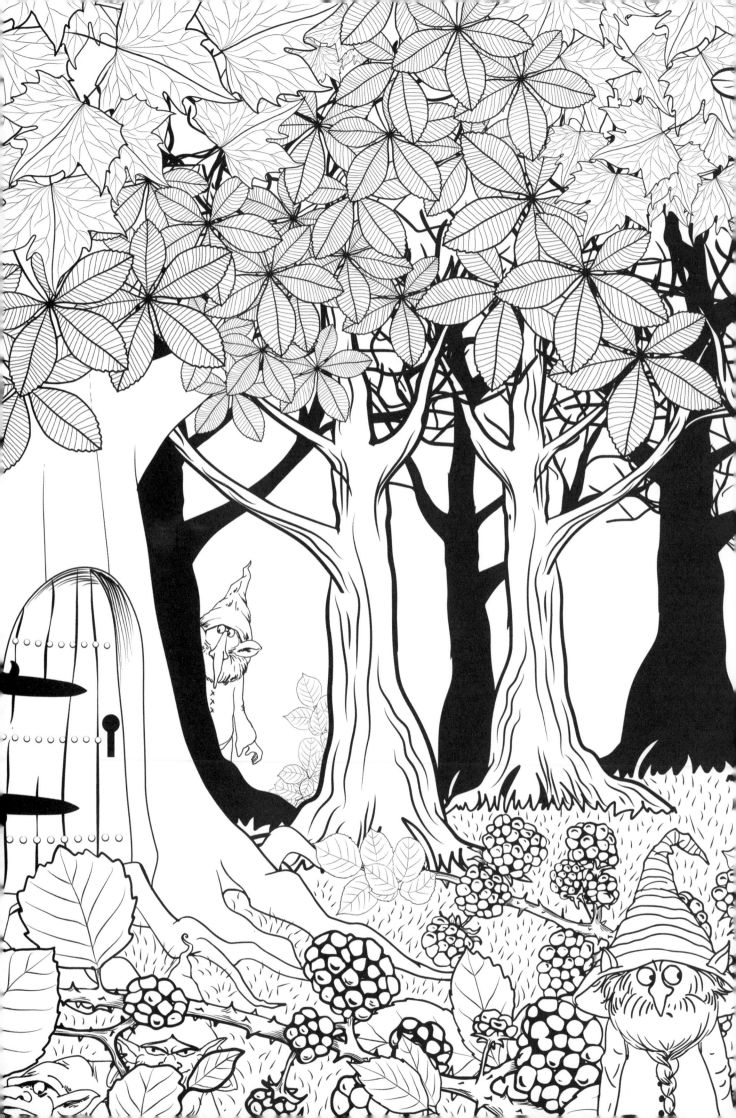

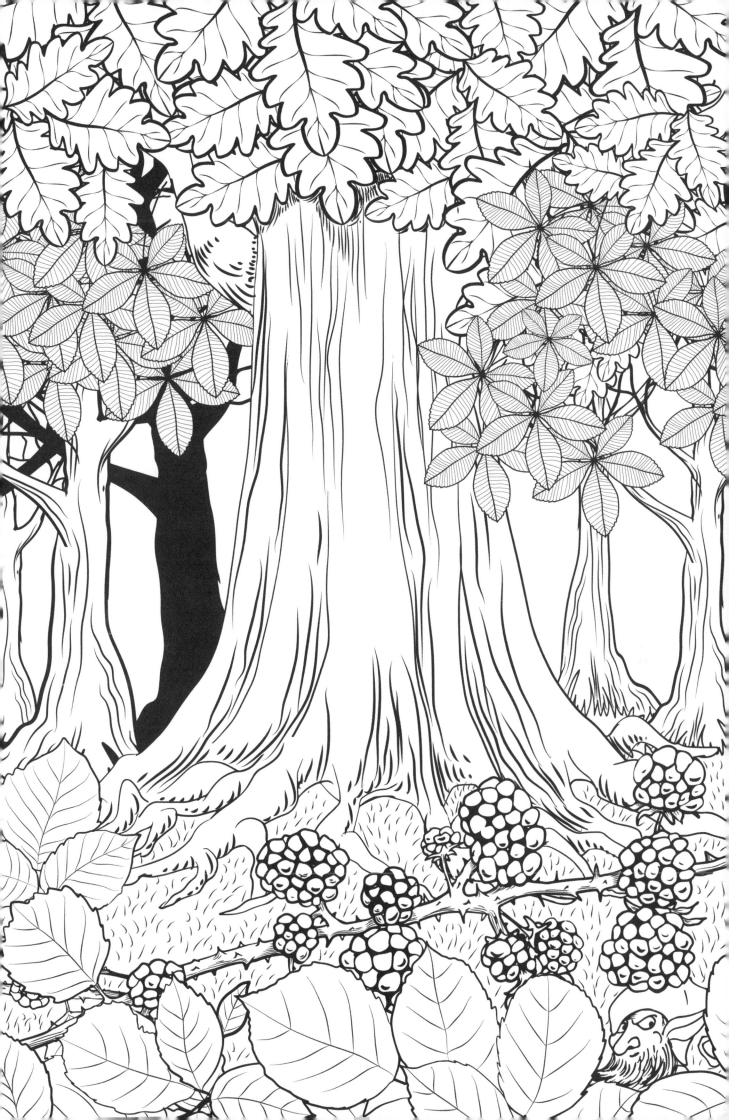

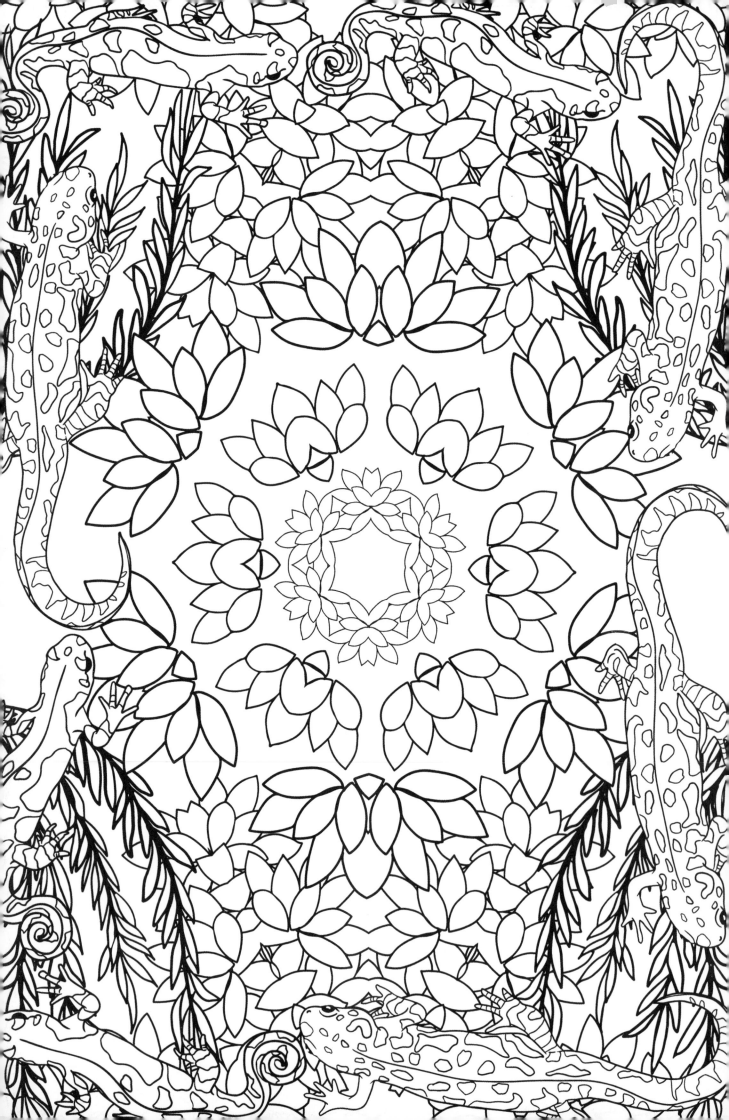

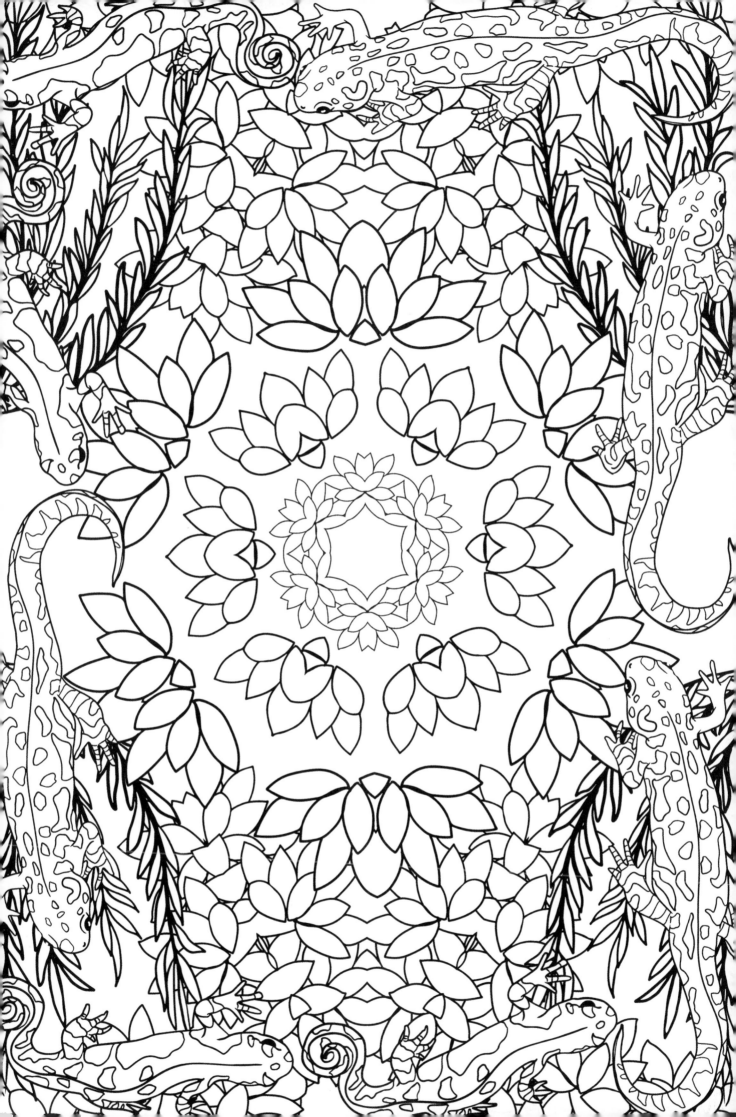

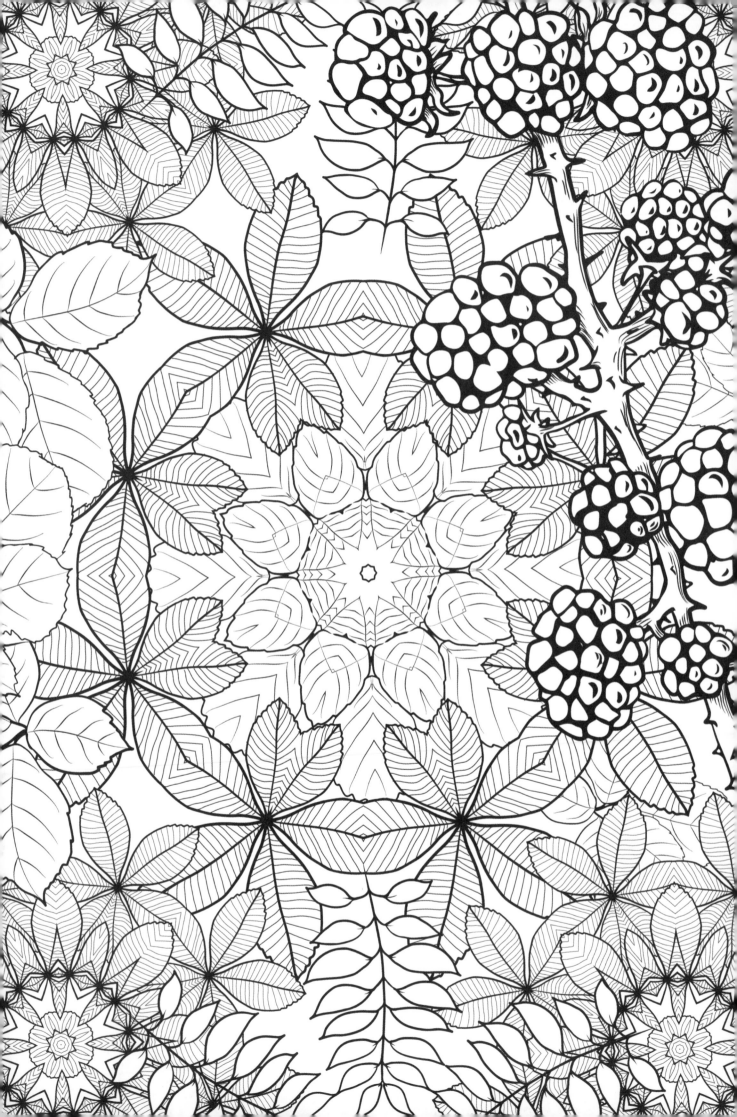

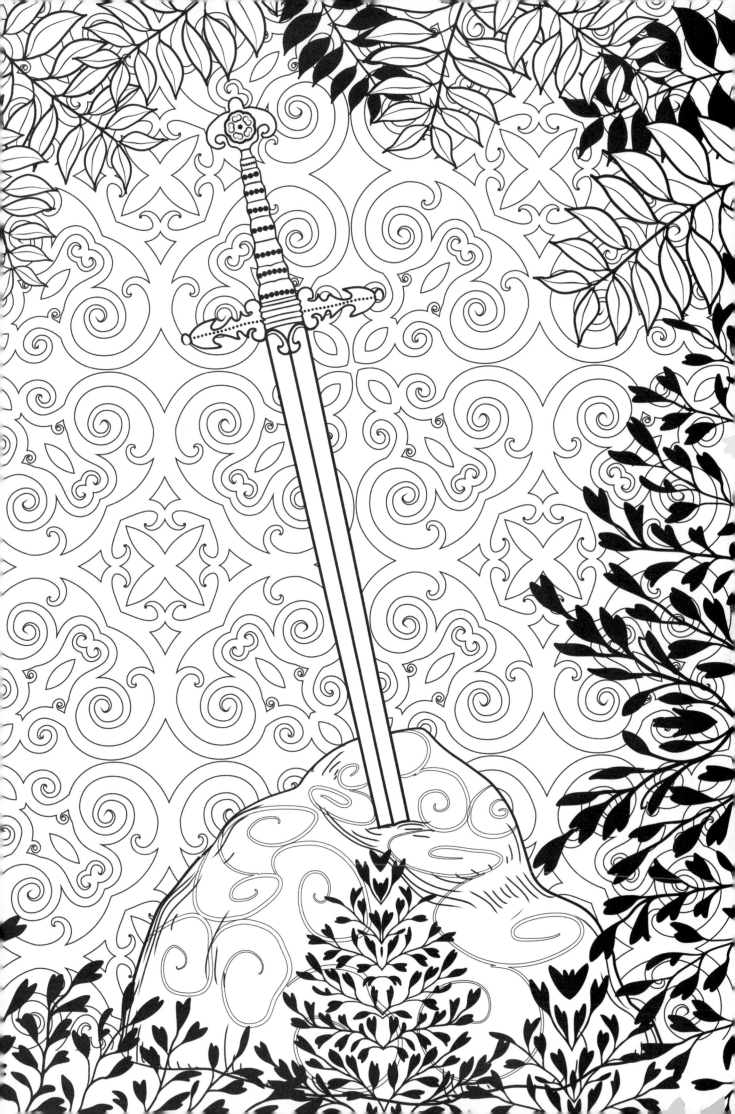

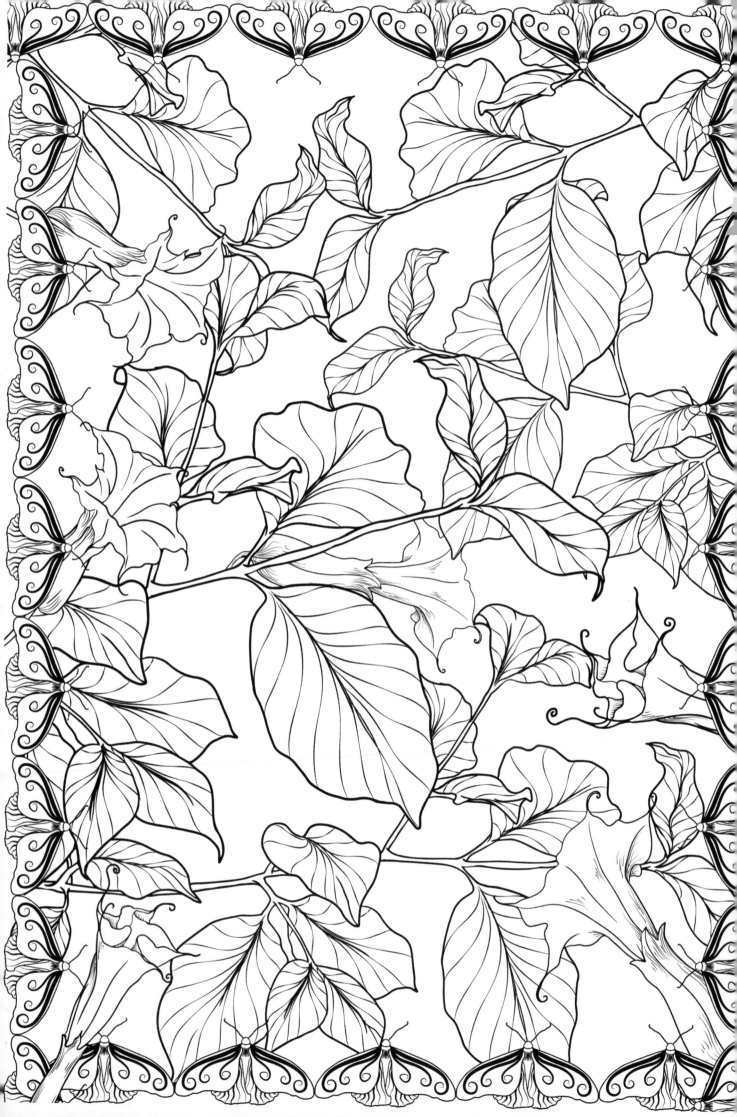

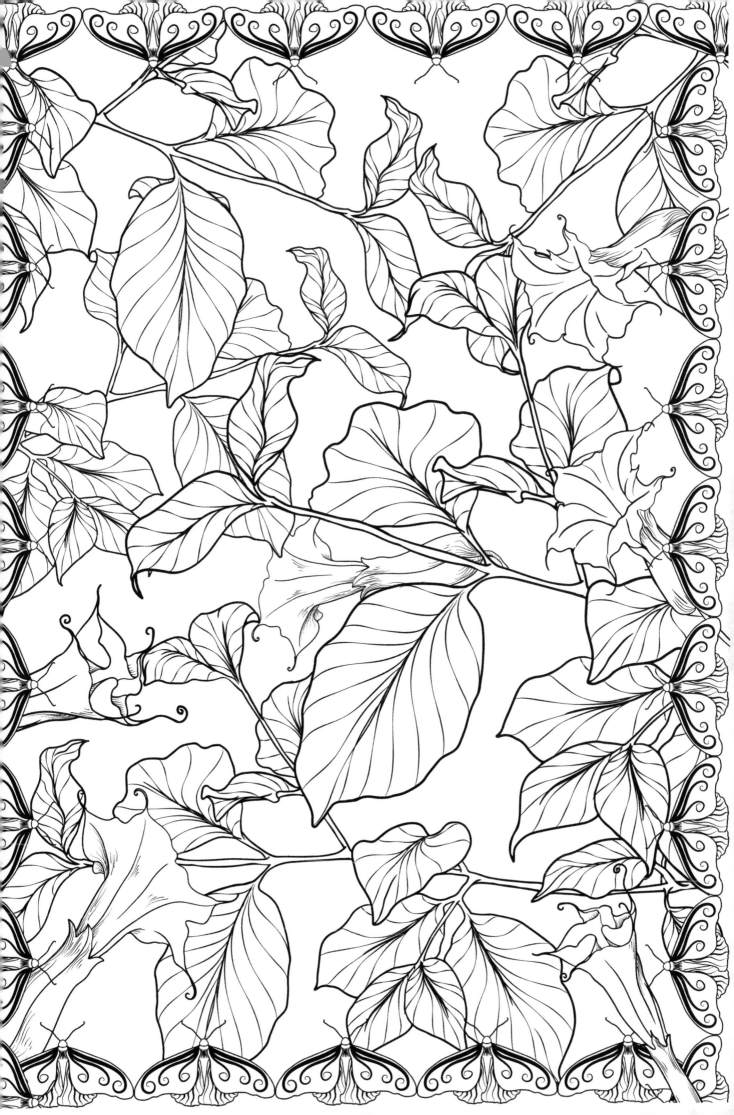

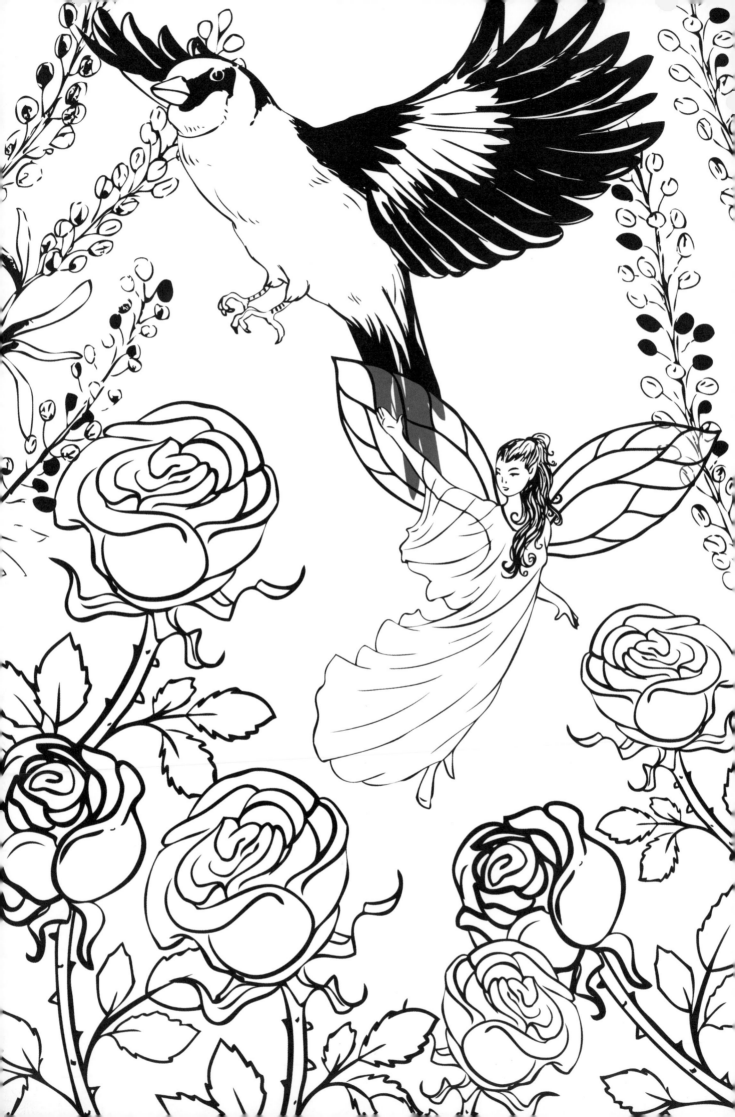

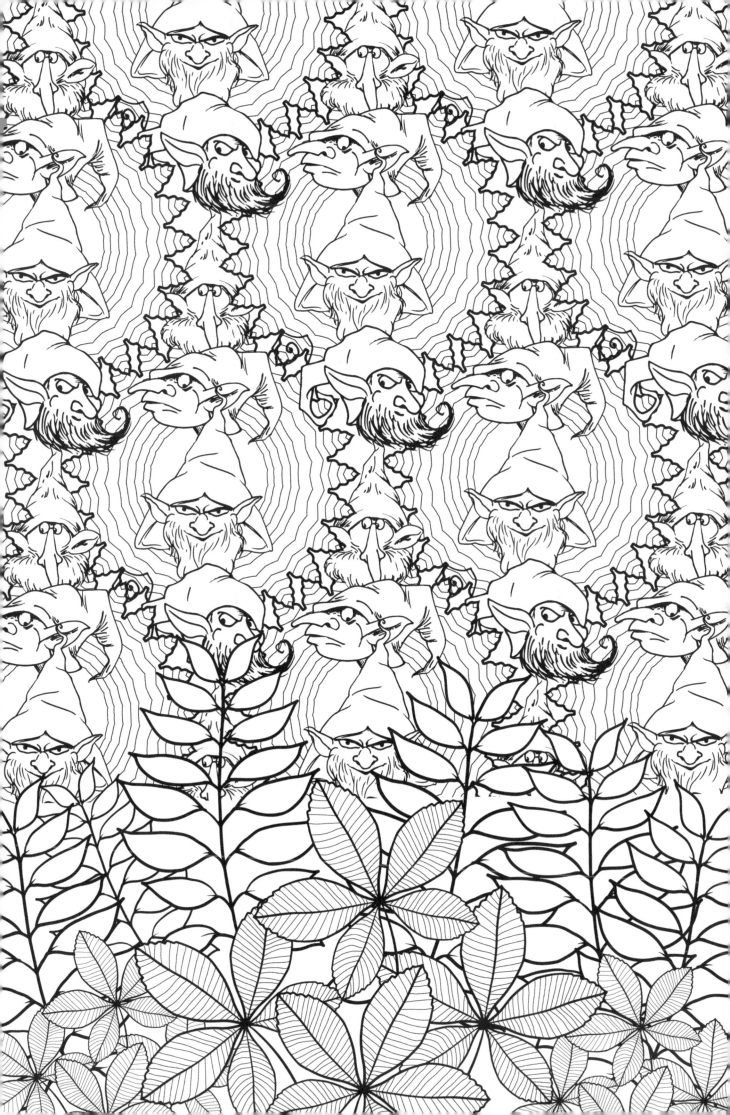

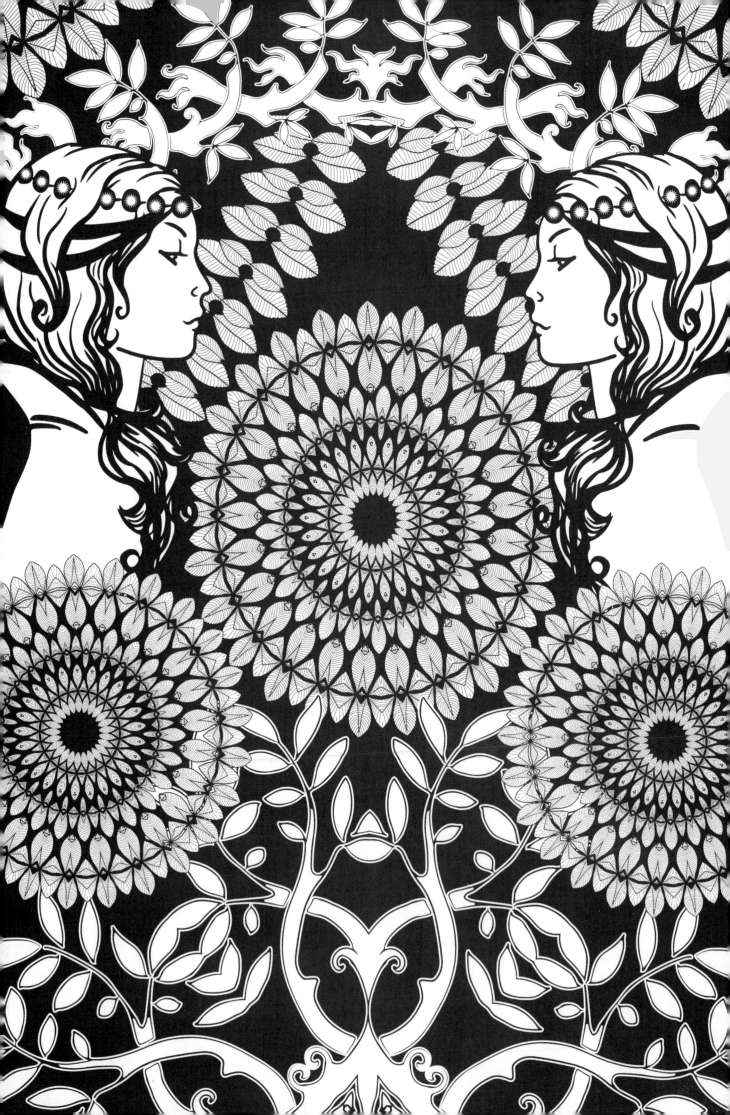

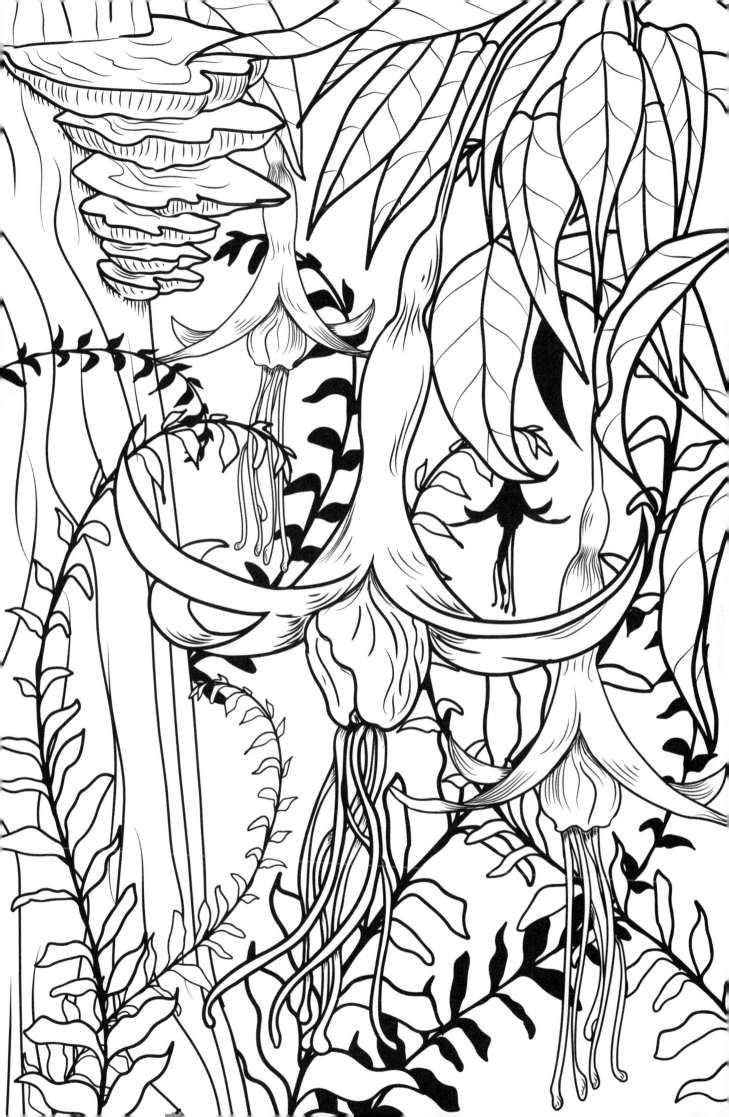

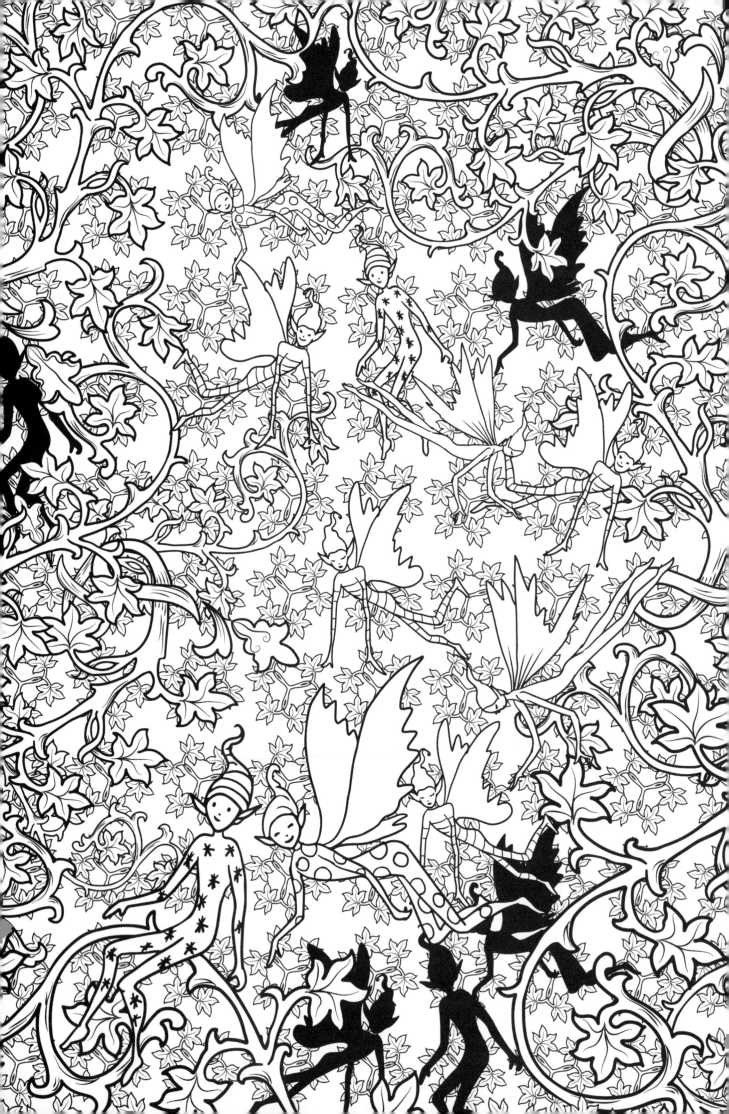

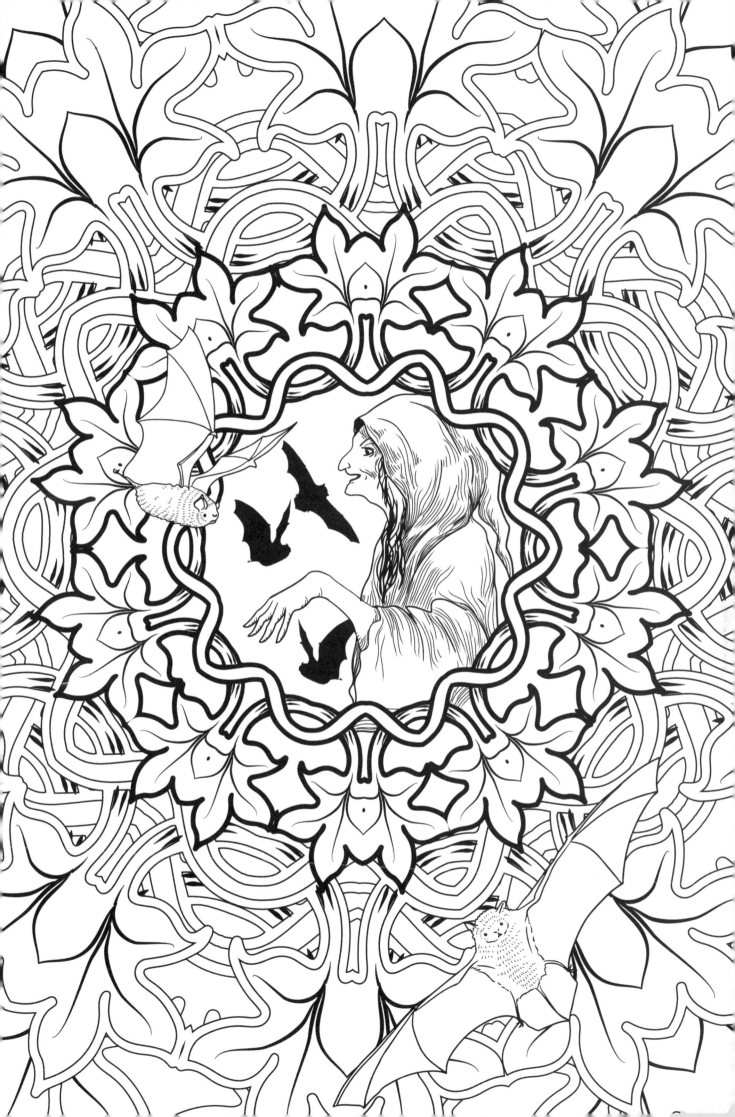

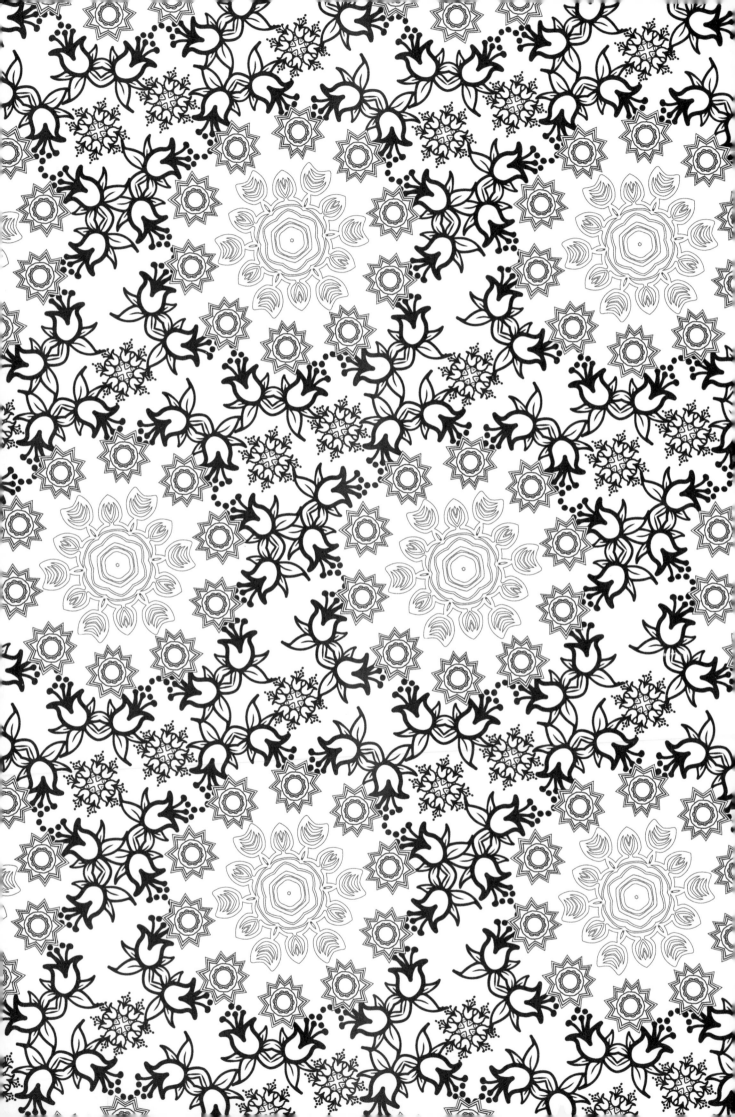

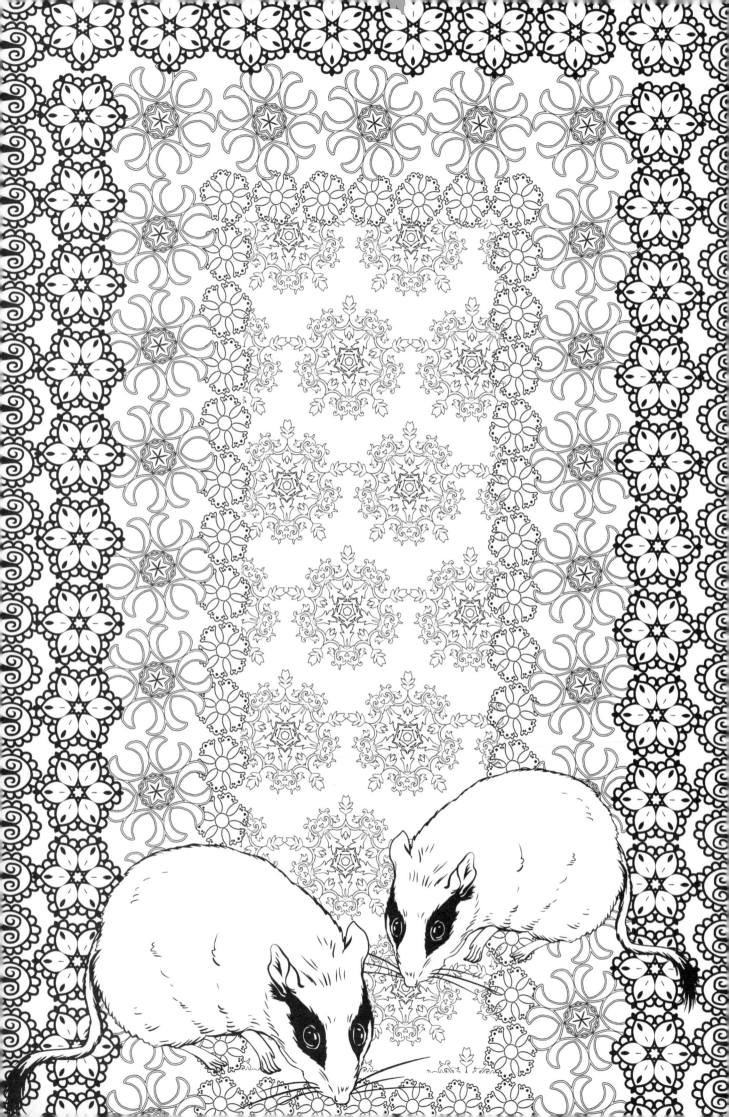

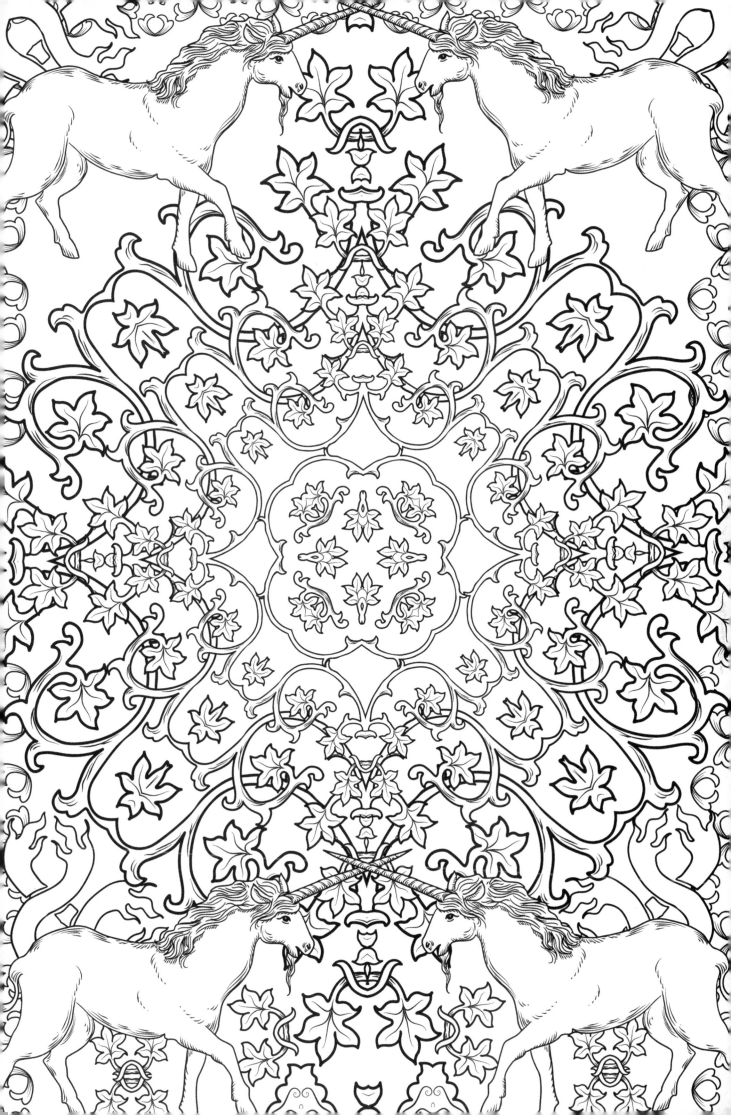

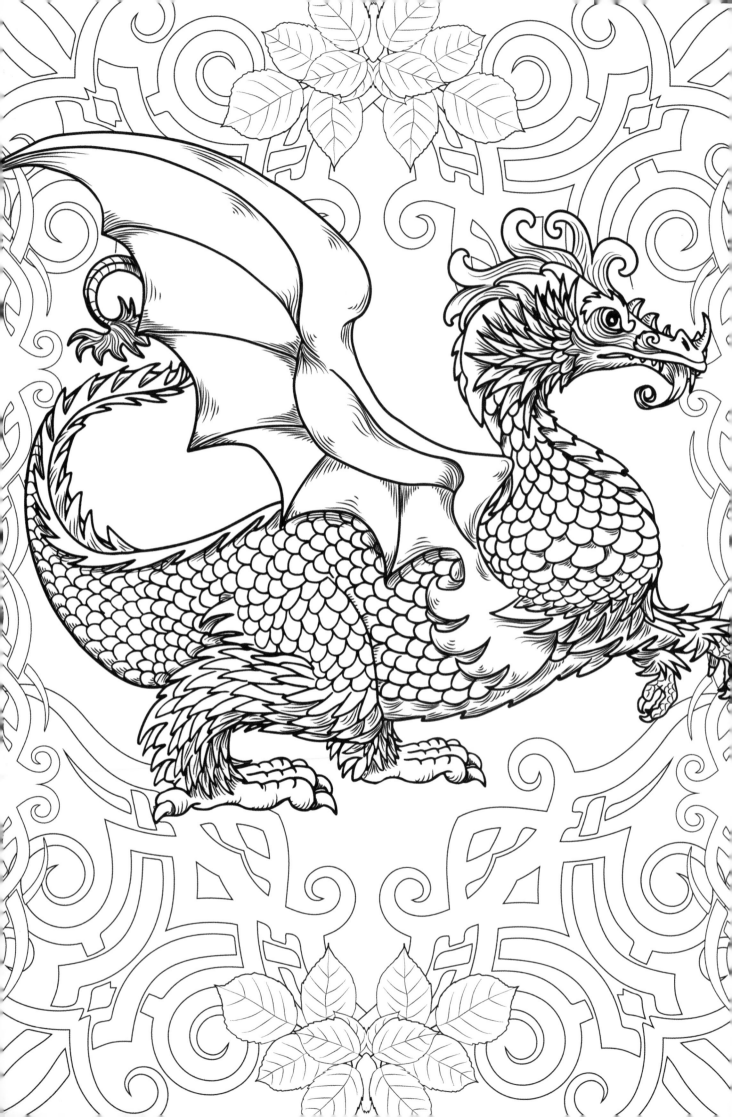

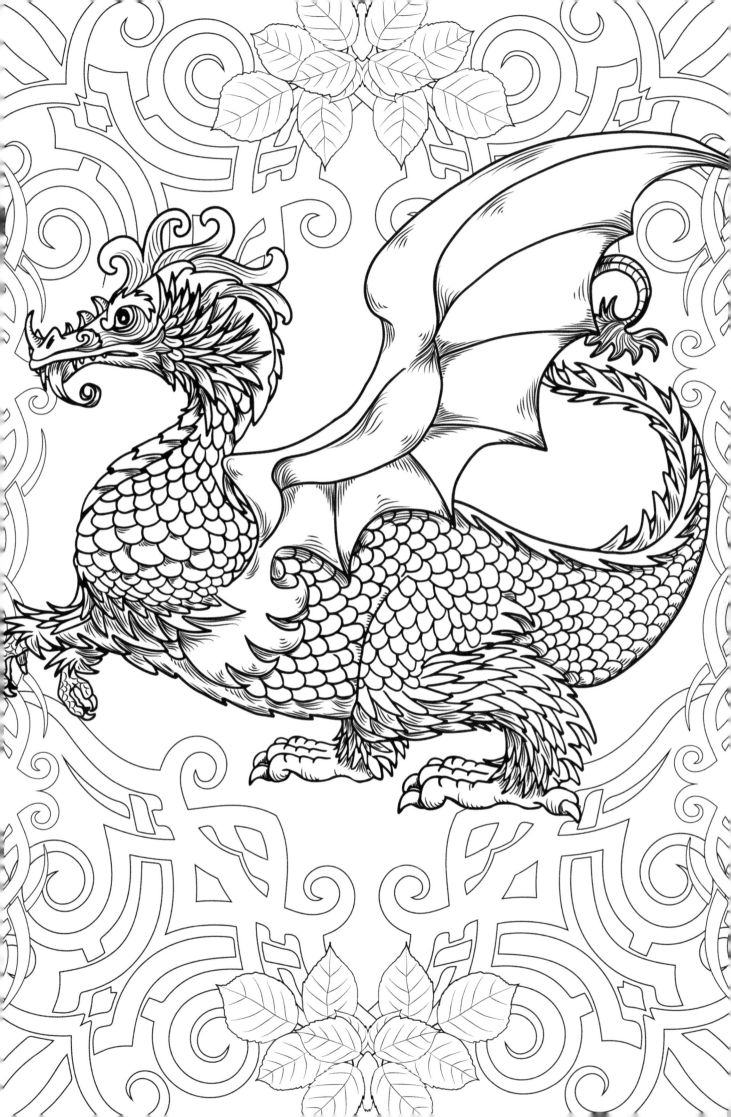

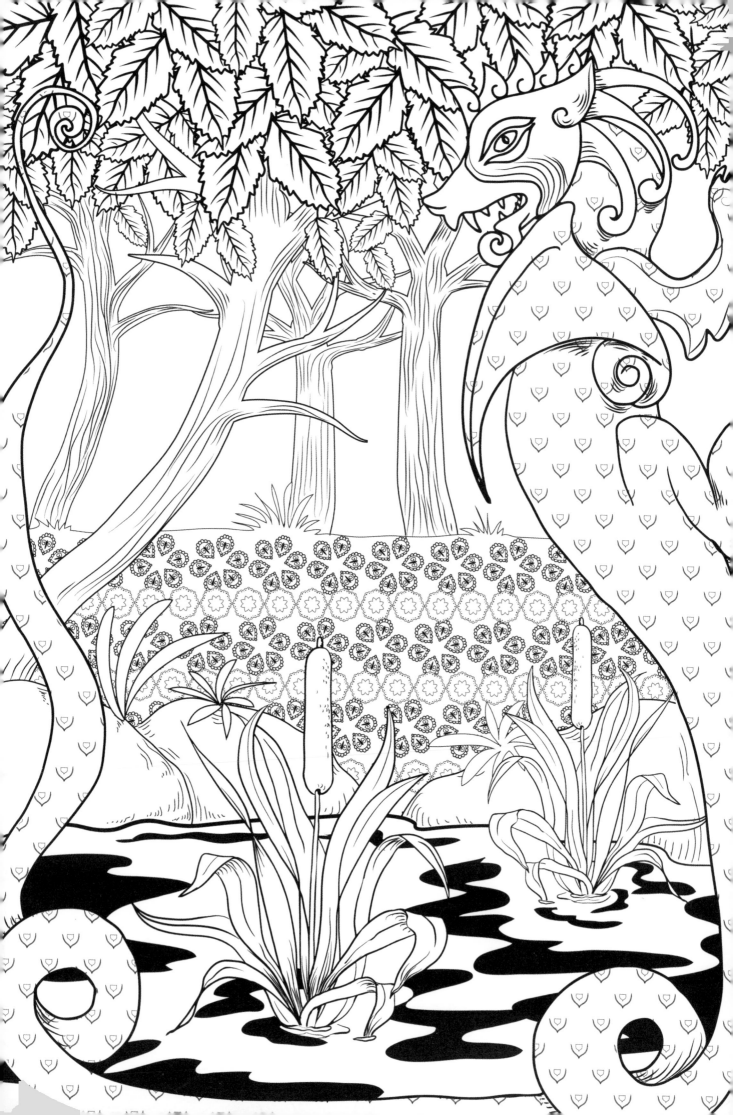

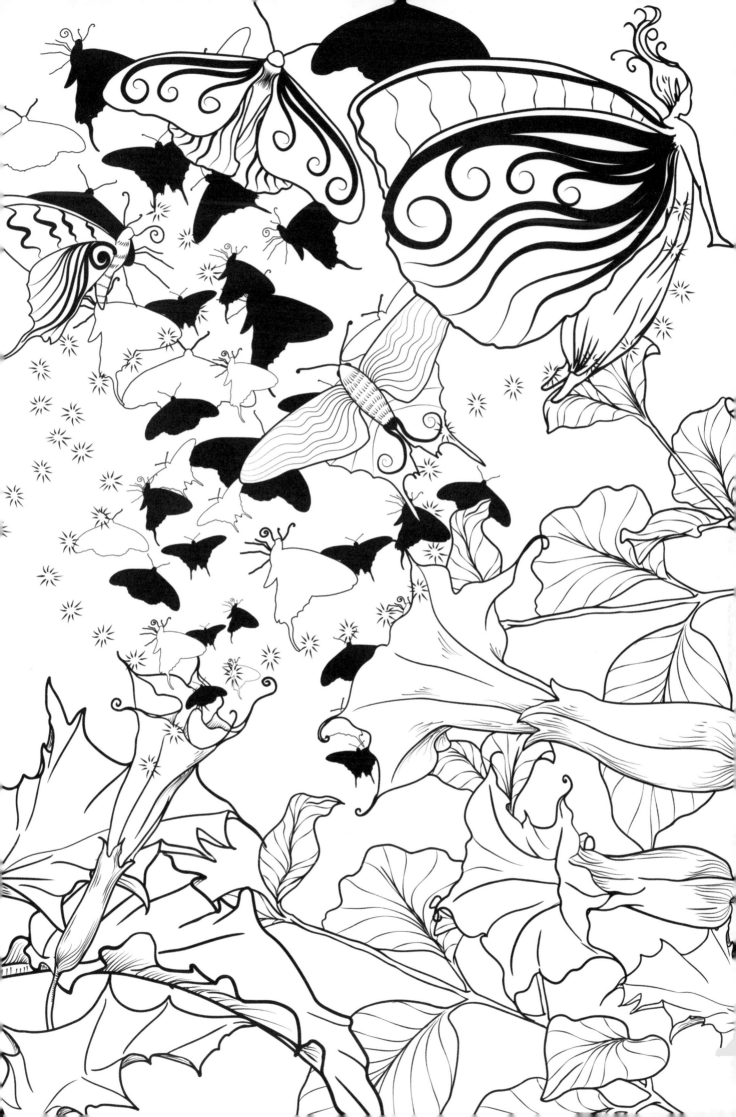

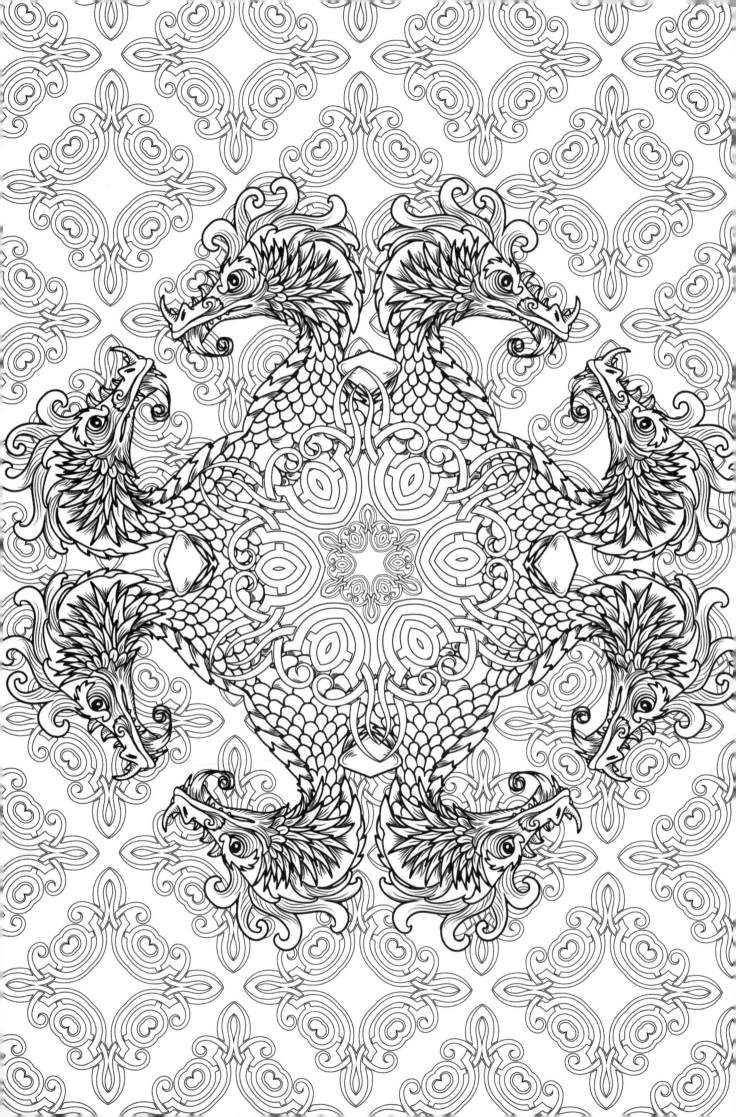

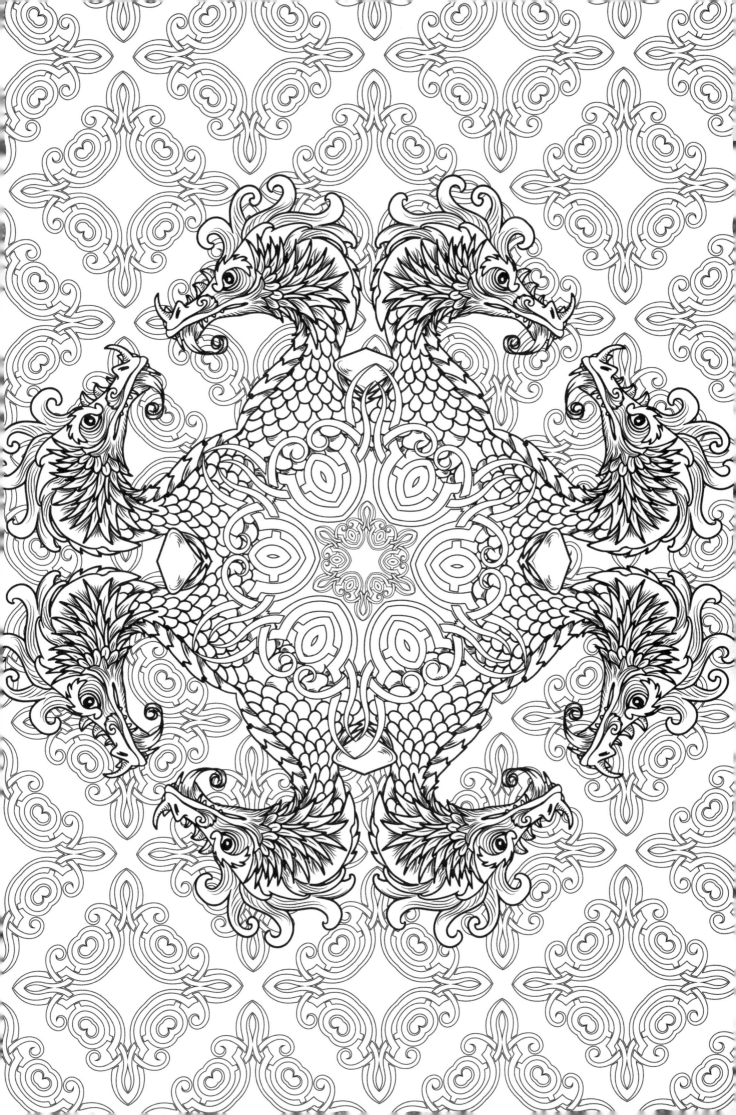

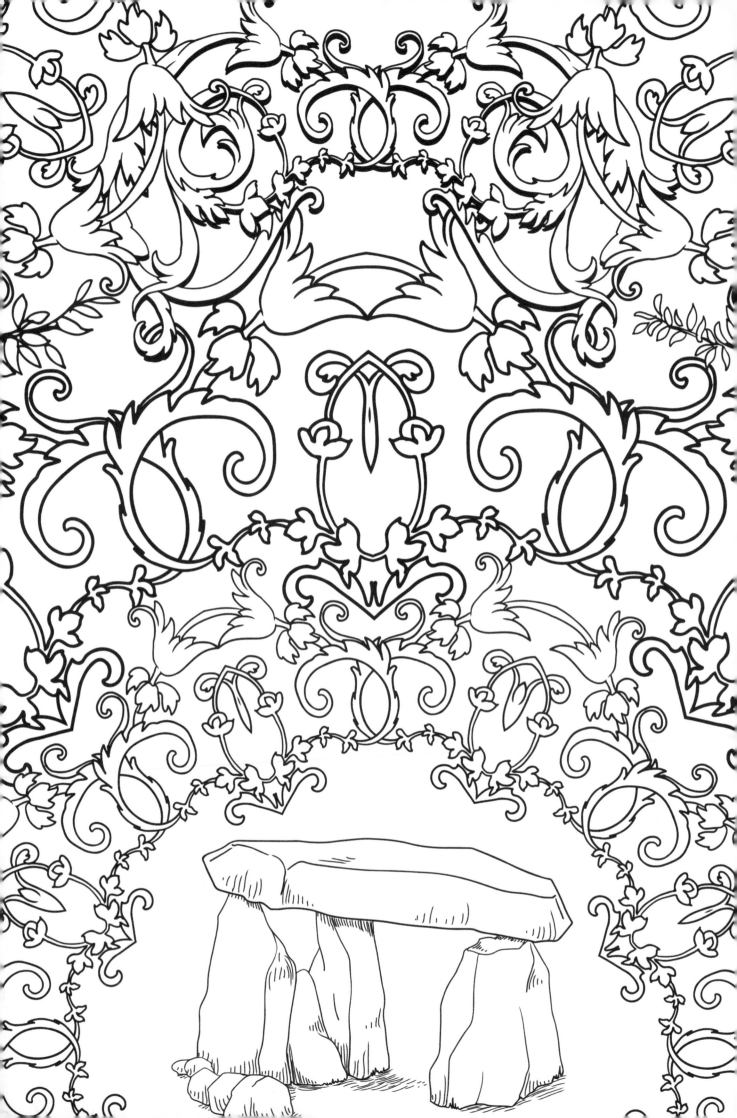

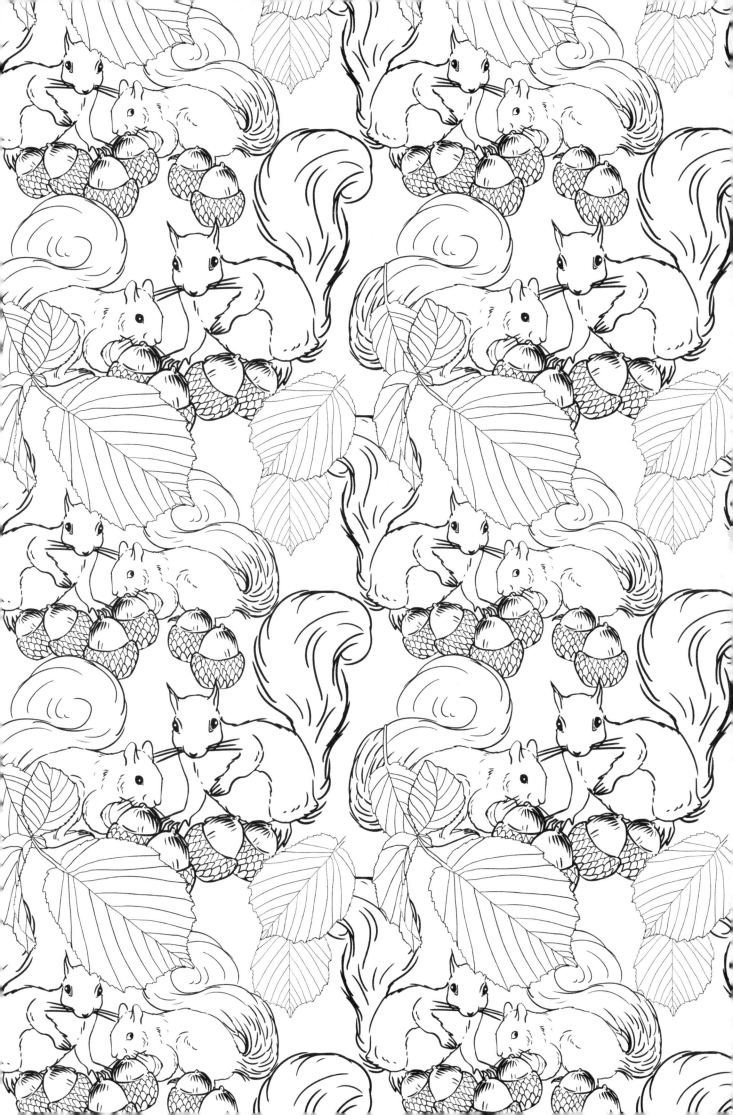

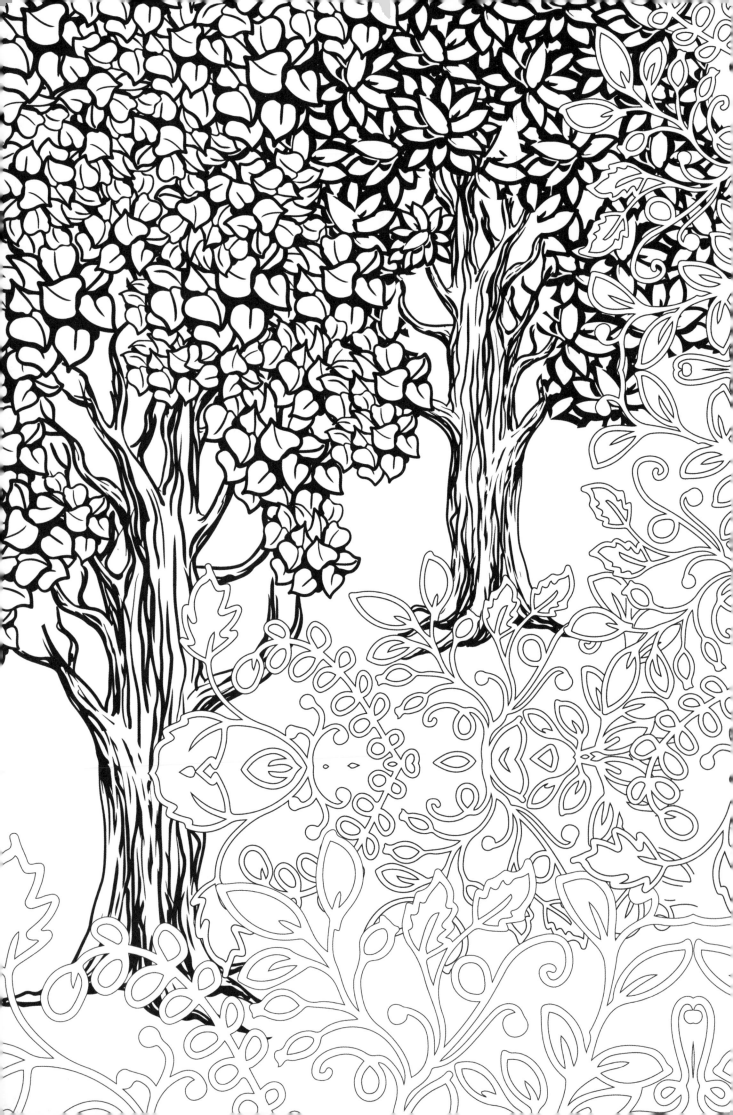

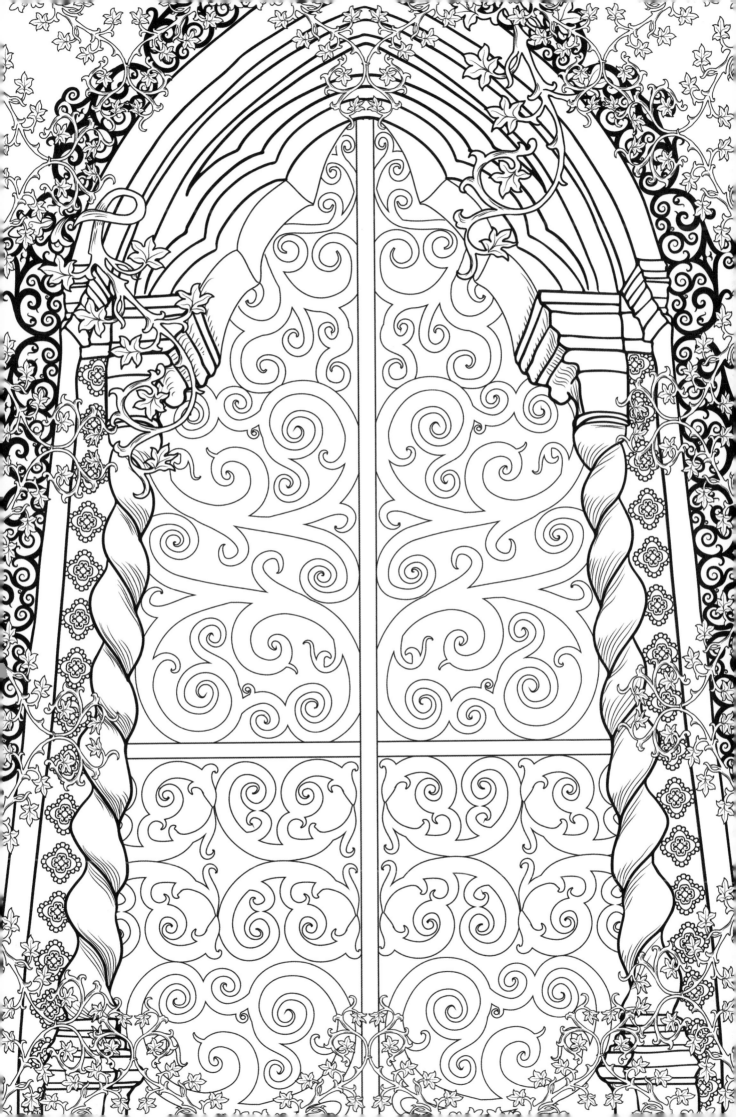

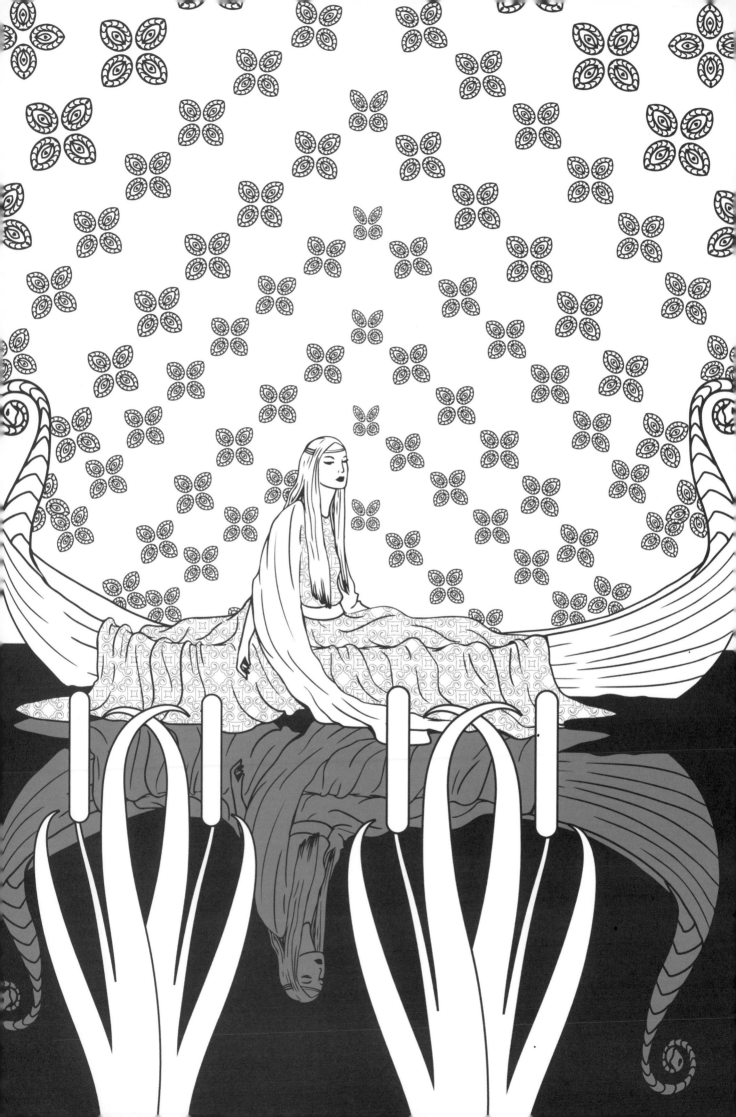

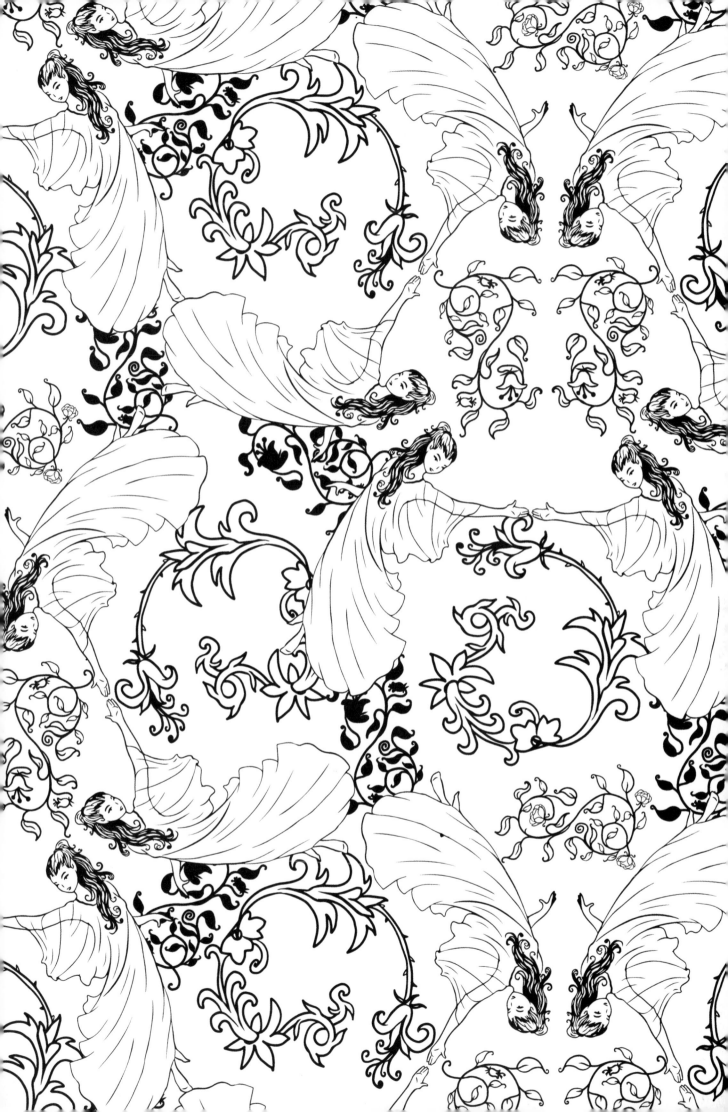

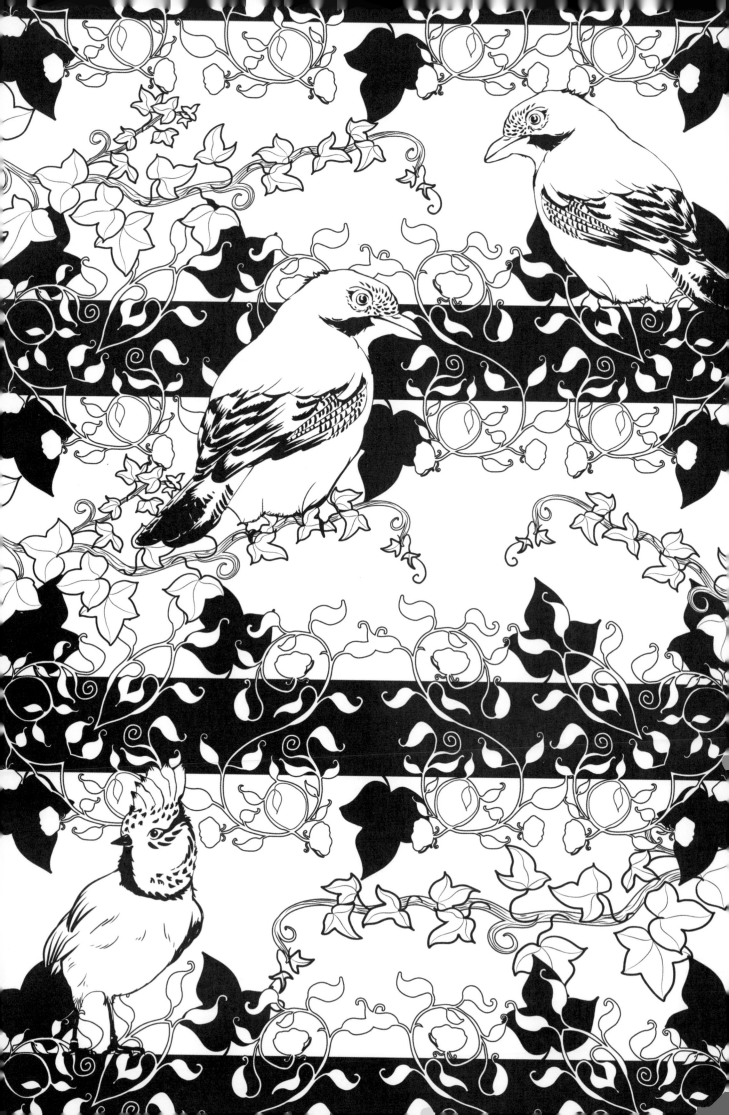

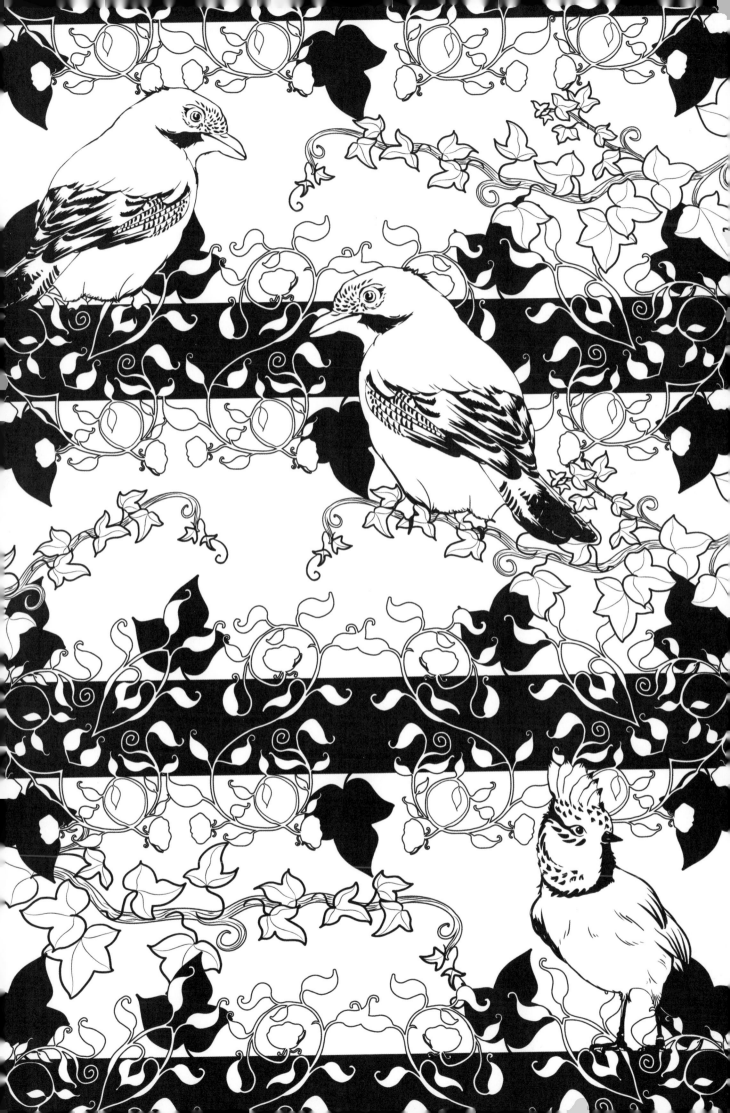

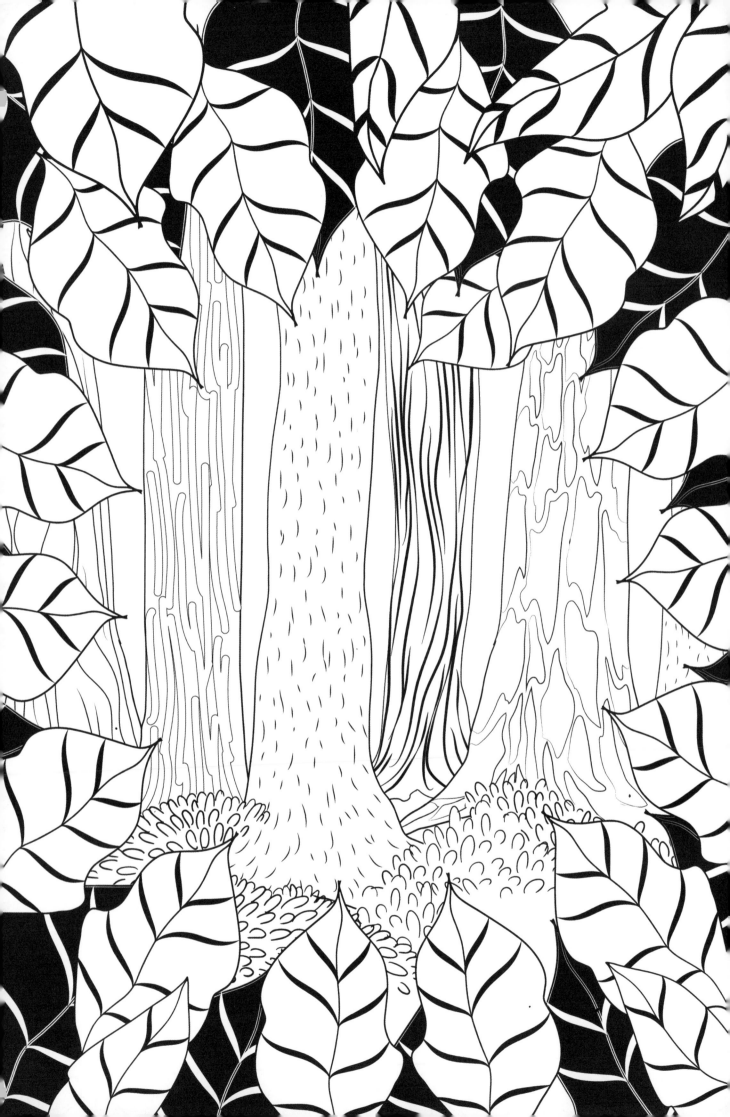

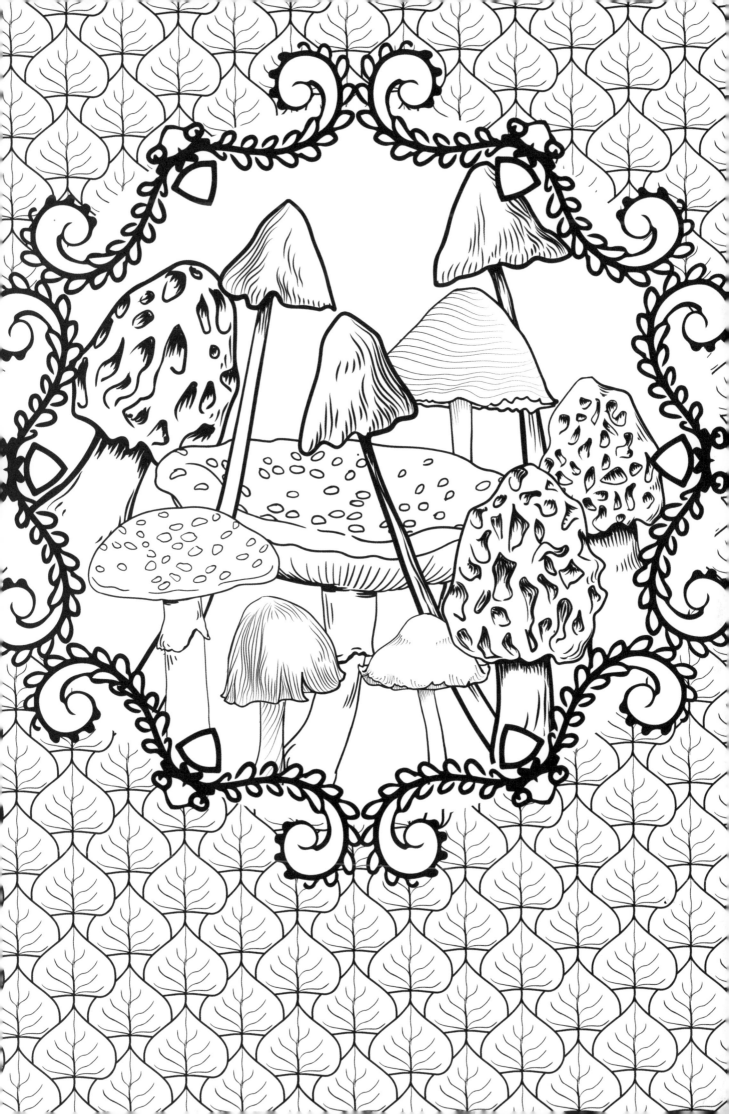

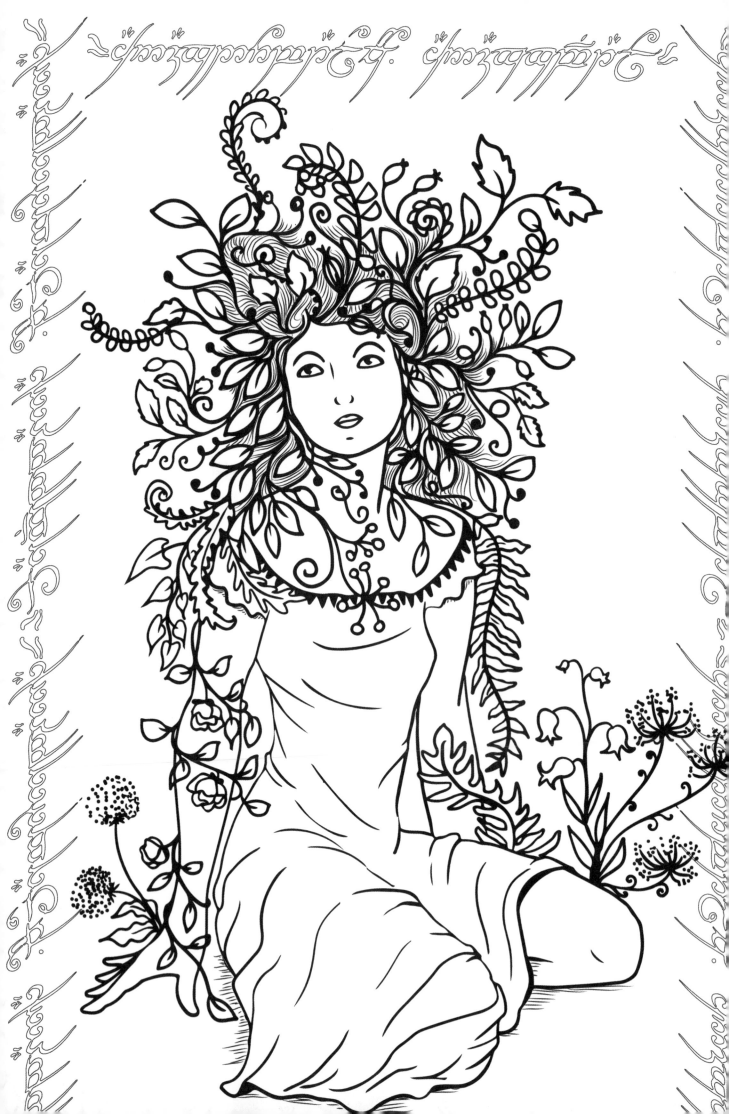

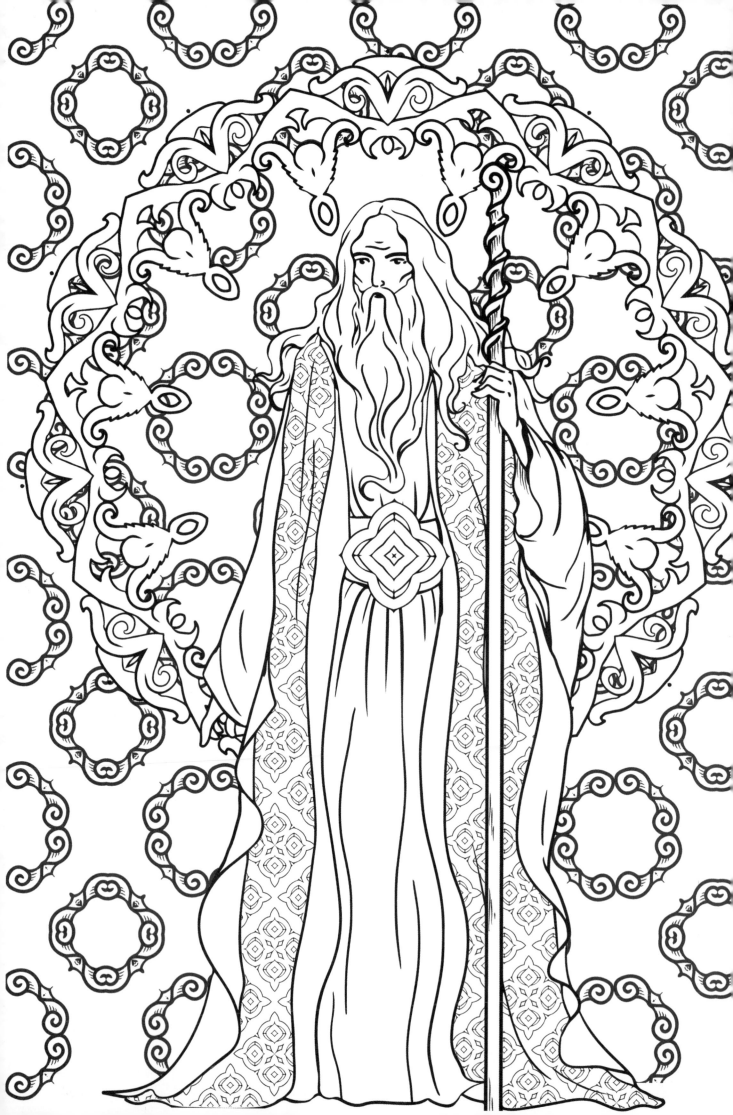

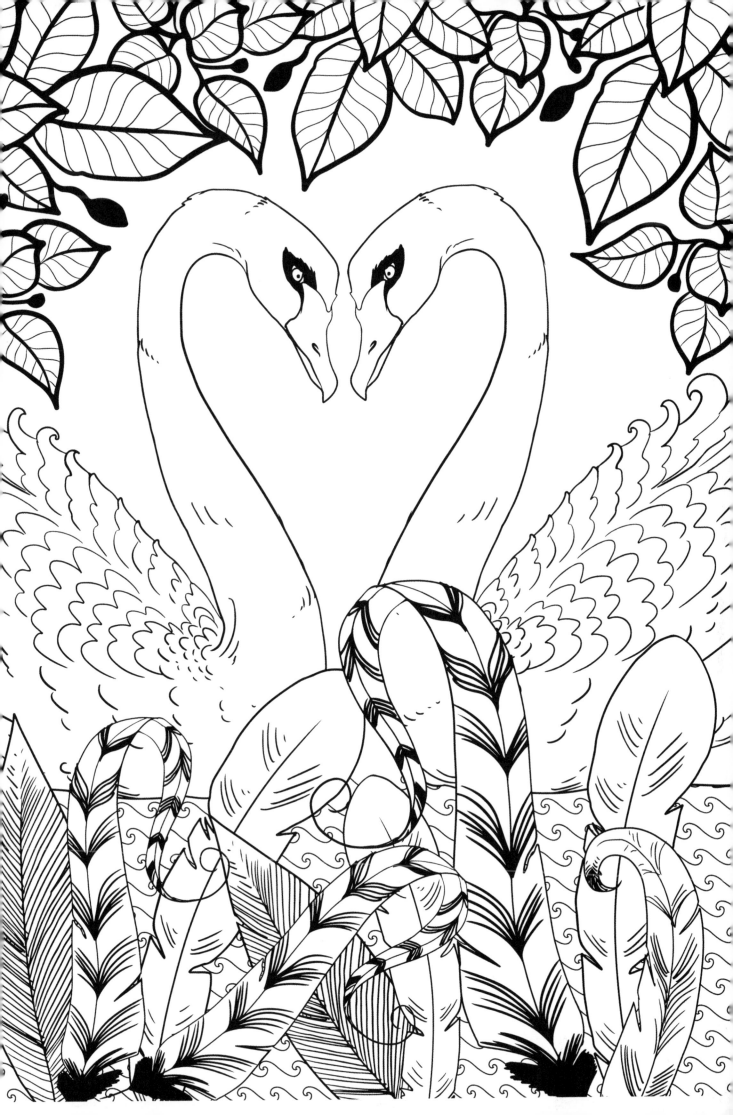

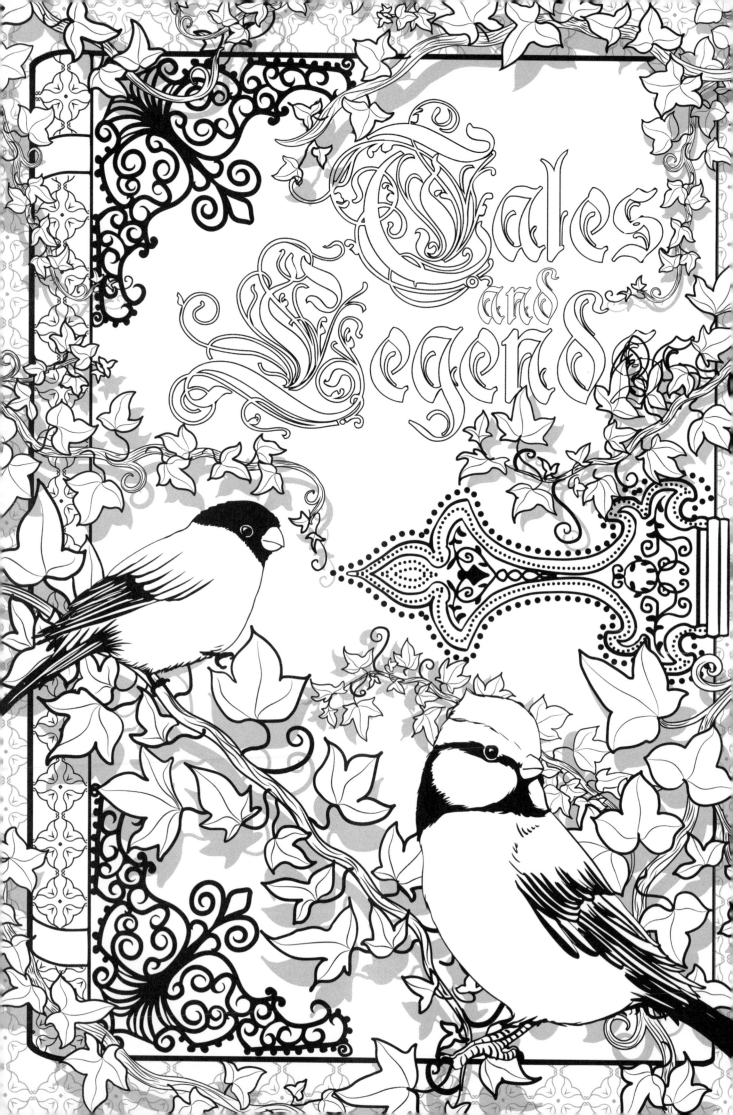

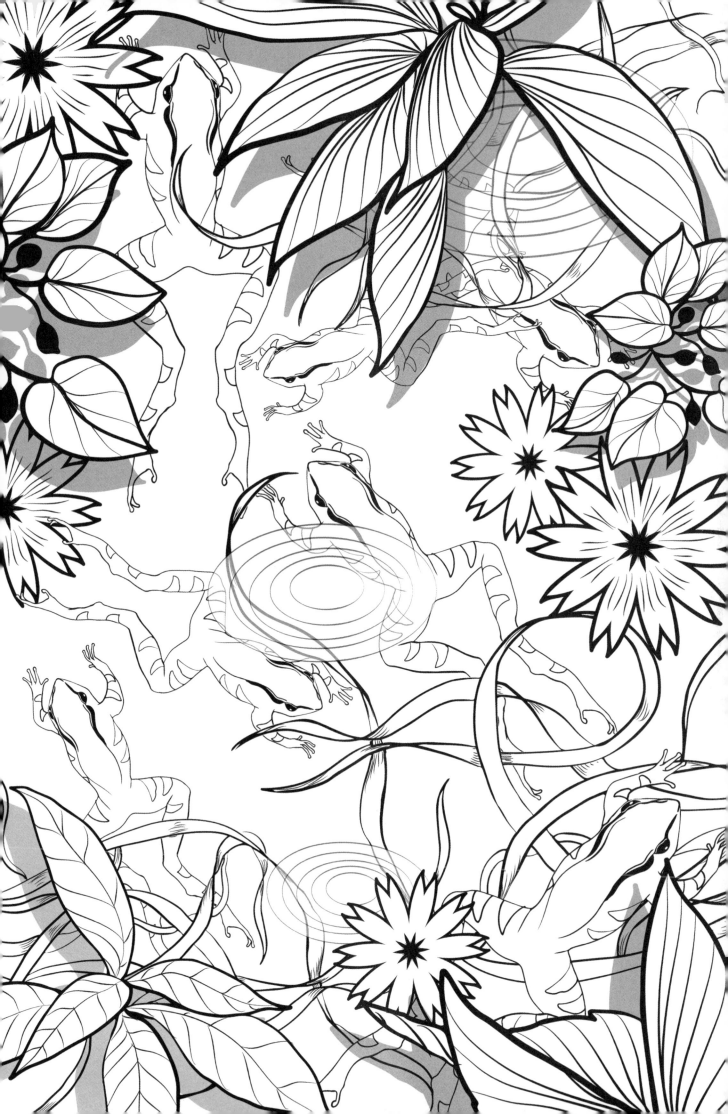

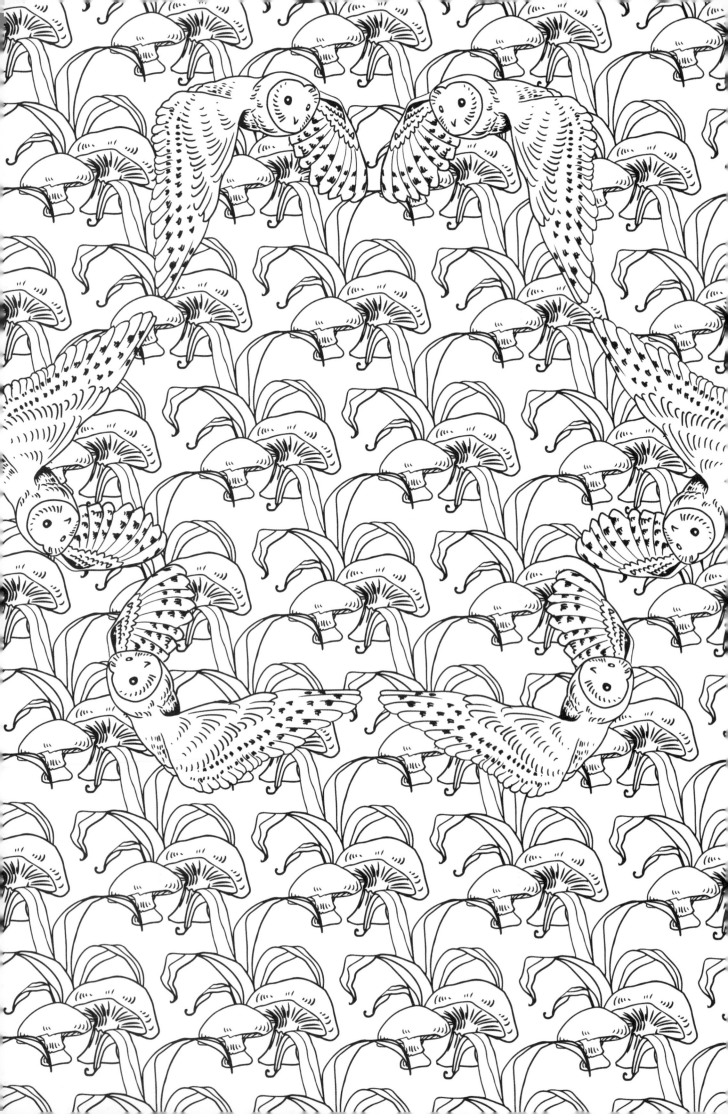

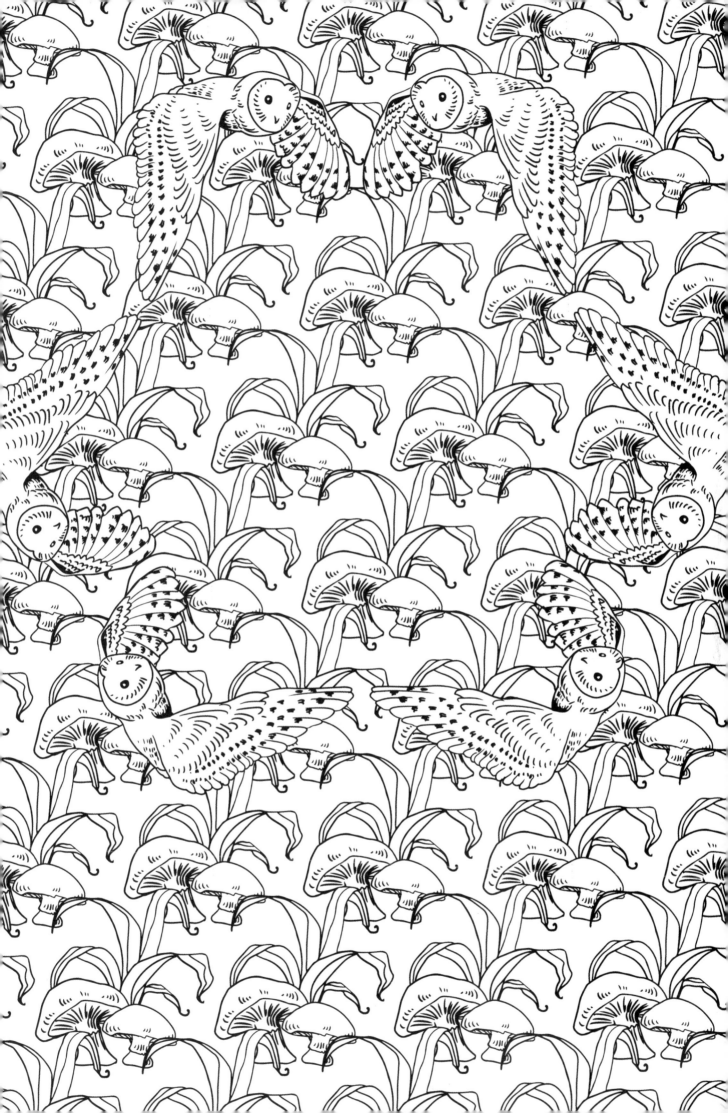

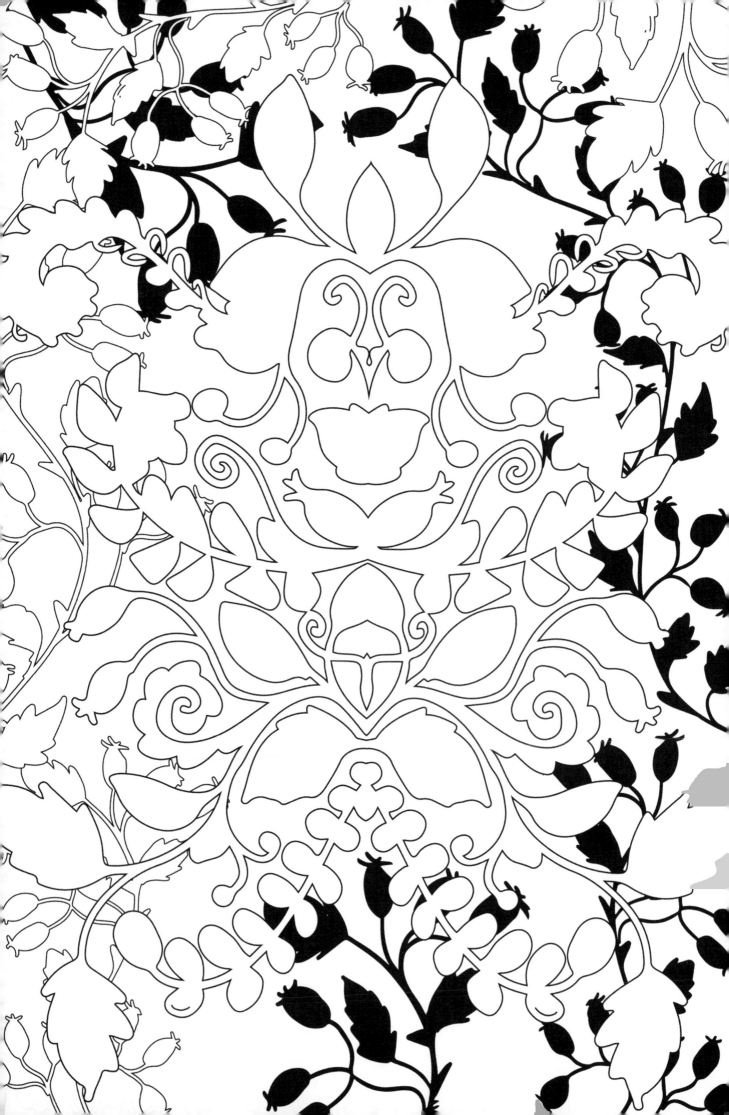

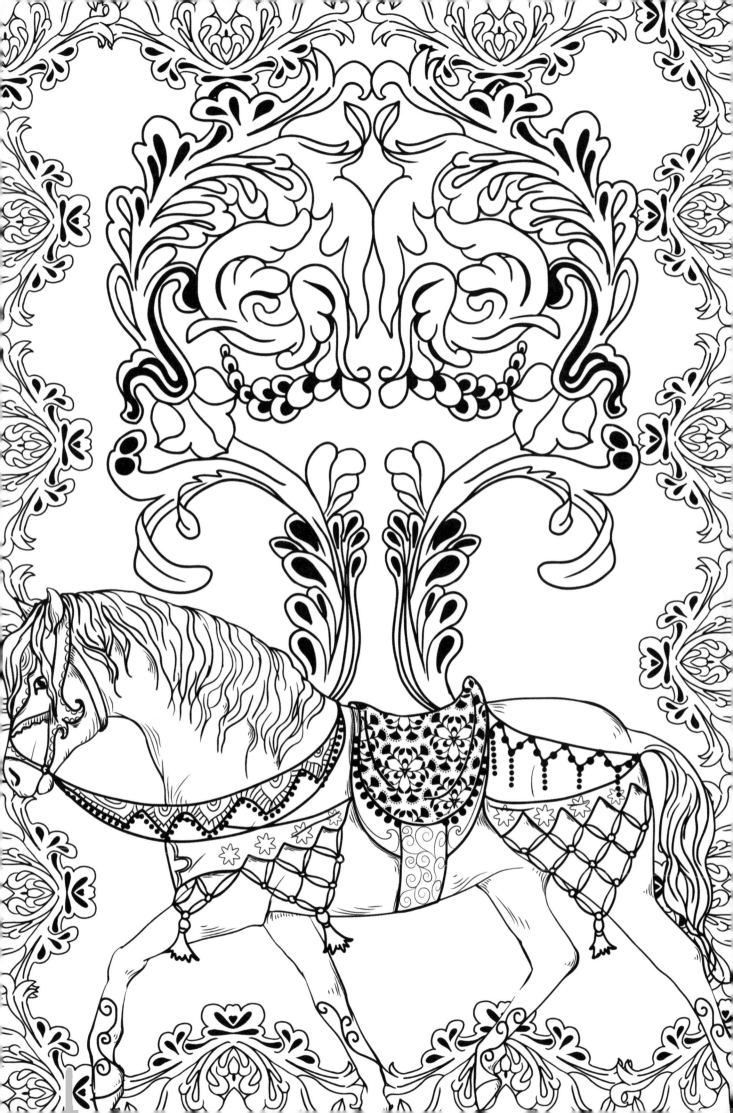

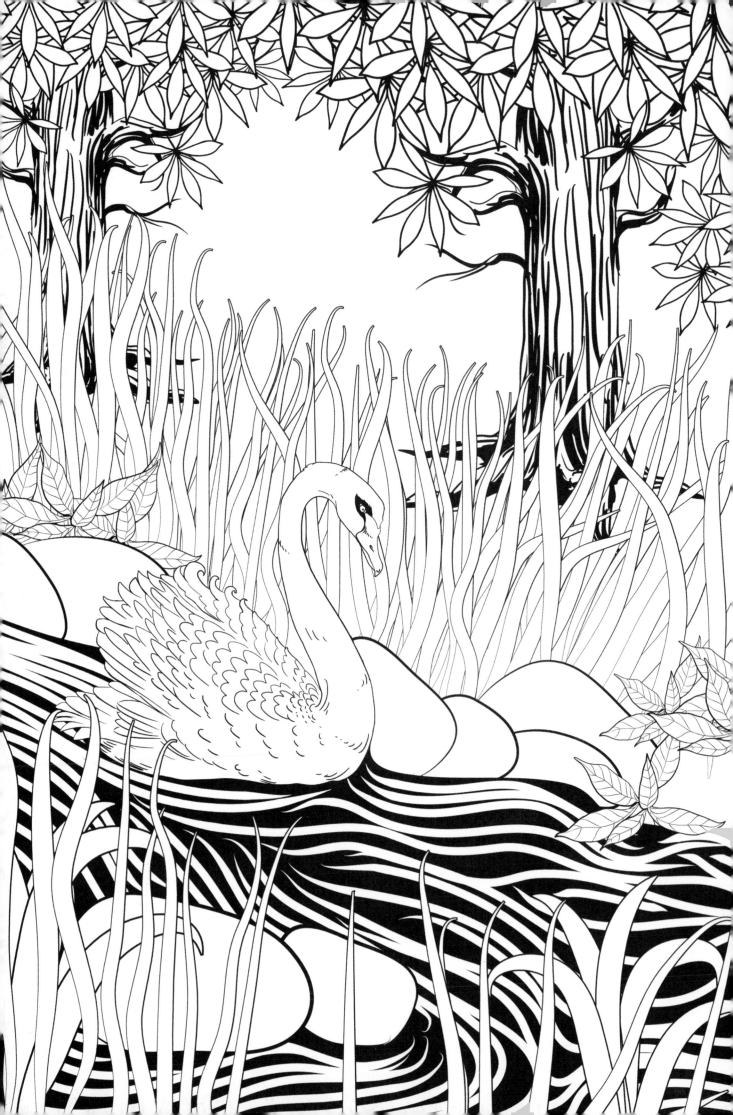

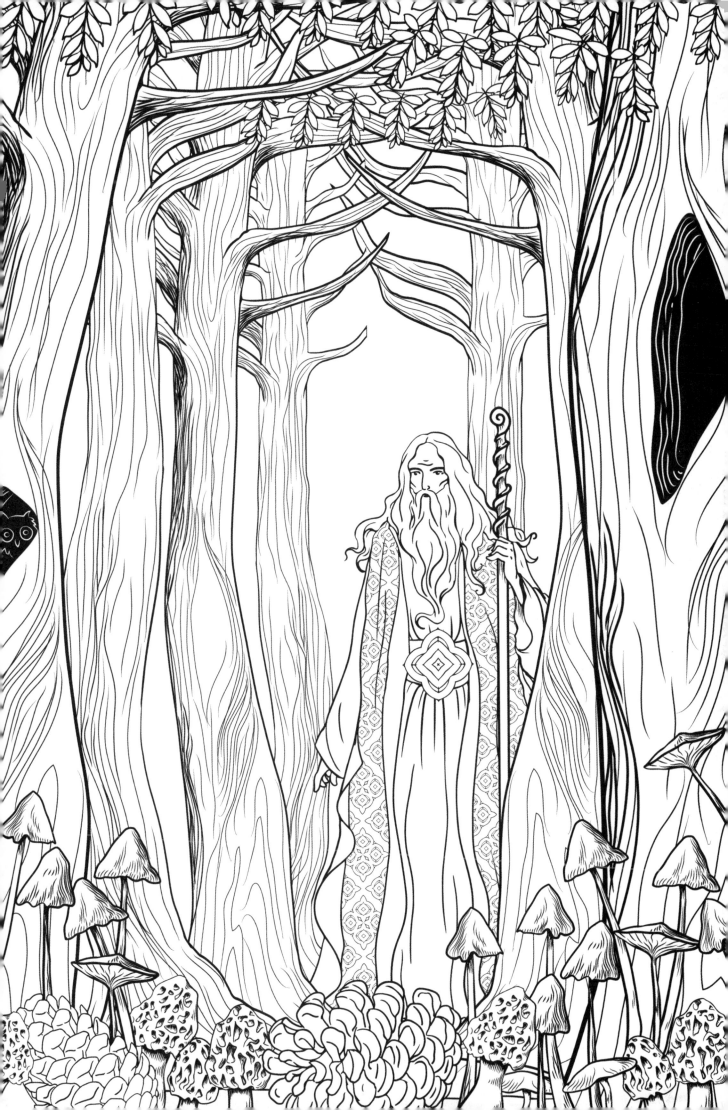

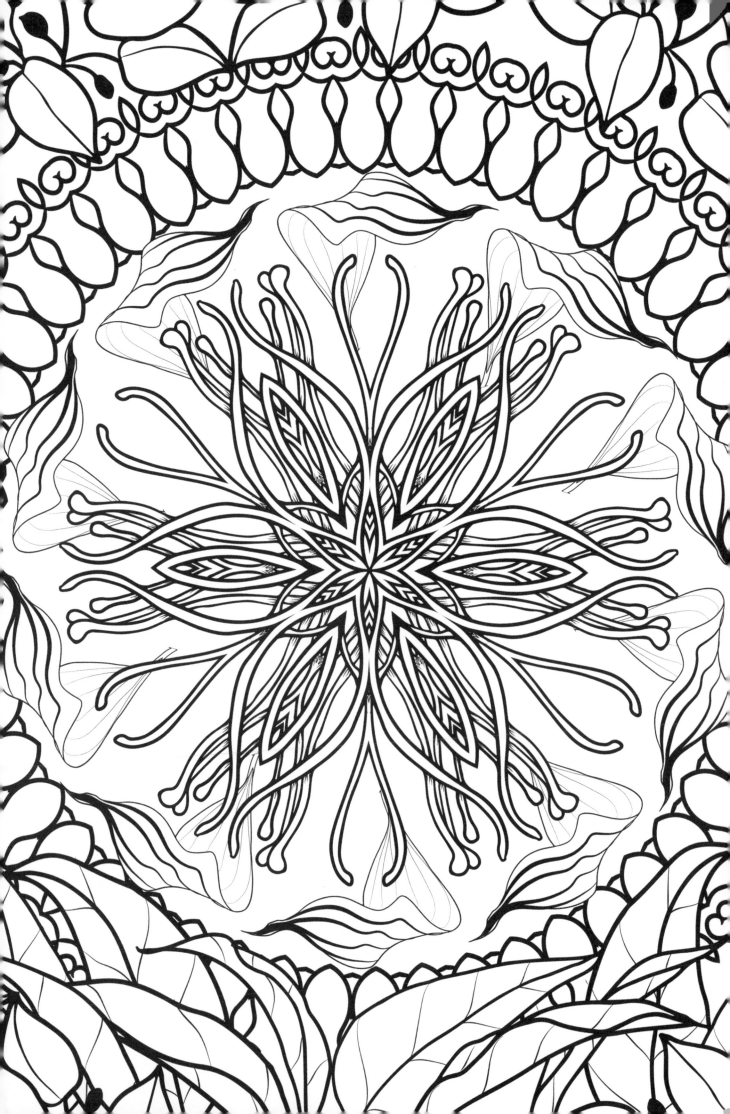

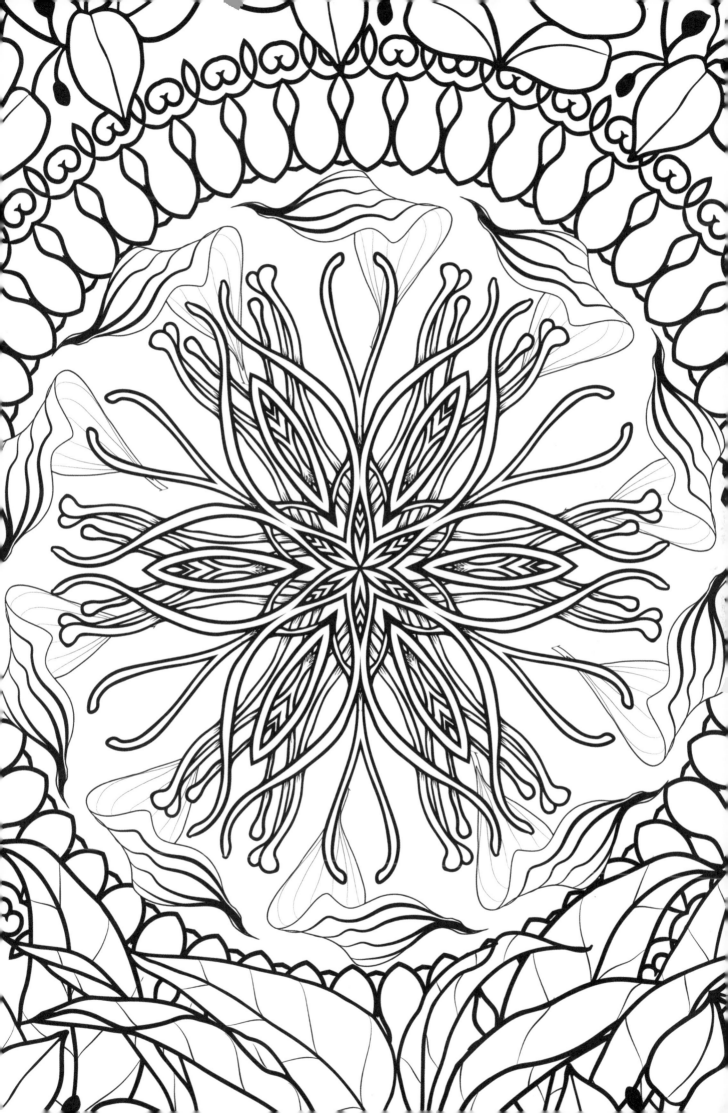

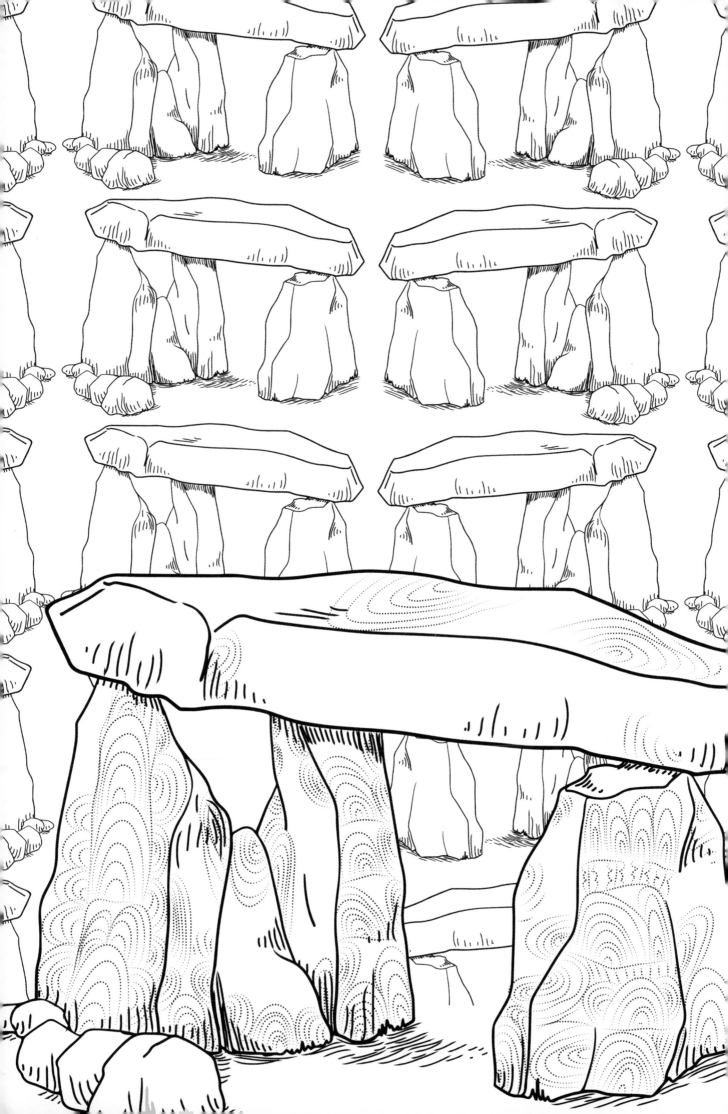